EDINBURGH ILLUMINATED

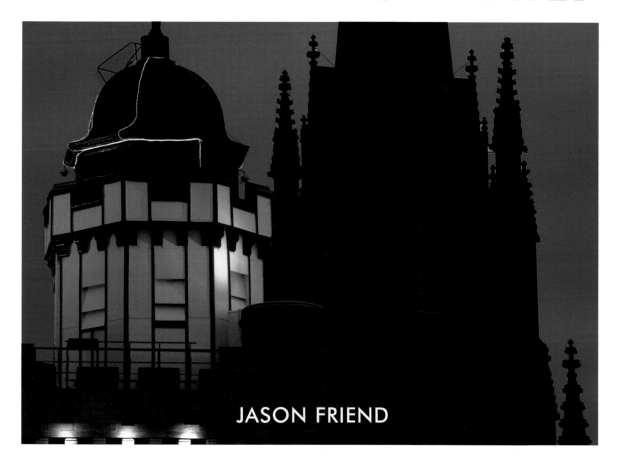

JASON FRIEND

HALSGROVE

First published in Great Britain in 2009

Copyright © Jason Friend 2009
All images in this book are © Jason Friend / Jason Friend Photography Ltd.
Prints are available of all of the images in this book via www.jasonfriend.co.uk/edinburgh.
Images can be licensed for commercial use at www.jasonfriendimages.co.uk.

British Library Cataloguing-in-Publication Data
A CIP record for this title is available from the British Library

ISBN 978 1 84114 887 8

HALSGROVE
Halsgrove House,
Ryelands Industrial Estate,
Bagley Road, Wellington, Somerset TA21 9PZ
Tel: 01823 653777 Fax: 01823 216796
email: sales@halsgrove.com

Part of the Halsgrove group of companies
Information on all Halsgrove titles is available at: www.halsgrove.com

Printed and bound by Grafiche Flaminia, Italy

Introduction

Edinburgh, Dunedin, Auld Reekie or Athens of the North – regardless of your choice of name to use, it is unquestionable that the capital city of Scotland is one of the most spectacular cities to be found within the United Kingdom, and indeed Europe. A city where the past is never far away yet the modern is always present. A city considered so unique that its future has been protected by the awarding of World Heritage status.

Edinburgh could be considered as a city of two towns, although the surrounding districts all have an influence on the character of this majestic place. Castle Rock dominates the skyline and has been used as a stronghold since the times of the Iron Age when a fort sat high on this ancient volcanic plug. Now it is replaced by the castle, a charismatic building visited by tourists from all around the world.

The Old Town maintains the charms of its medieval roots and boasts a number of historic buildings to be found along the spine road of the Royal Mile, linking the Royal Palace of Holyroodhouse with the Castle. Steep roads and narrow alleyways span from here forming a web of historic locations for the visitor to explore. There are even more surprises to be found underfoot with tales of a forgotten city deep underground which has only recently started to be fully explored.

The organised structure of the New Town is a complete contrast to the chaotic design of the Old. Designed with a view of relieving the overcrowding problems of the Old Town, this area of the city is home to some fine architecture including the buildings of Charlotte Square, considered by many to be one of the finest Georgian squares in the world.

The first account of the game of golf is credited to the Leith Links, site of an historic battlefield from a time when Leith was a separate town from the city. Modern day Leith is known as the Port of Edinburgh, although it maintains its own individual character from the once neighbouring city of which it has now become a part.

During the light of day, the city of Edinburgh holds a charm that will delight any visitor or resident. Arguably, however, to fully appreciate the splendour of this city one has to experience its delights as it is transformed during the periods of darkness. As the sun sets the lights turn on, giving a new appearance to the streets and features, that could not have even been anticipated by the original architects. The powerful visual impact of this spectacle which is enjoyed by so many, is something that can only be fully appreciated by visiting the city itself; but in the meantime I hope these pages will give a taste of the glories that await.

Jason Friend

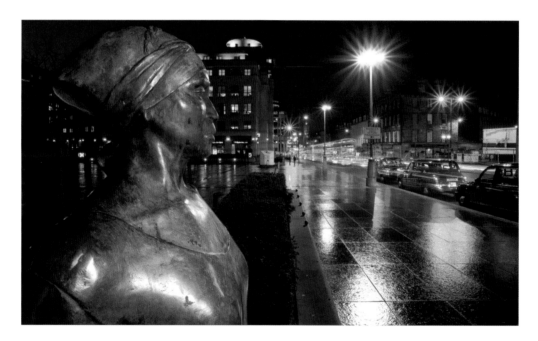

Acknowledgements

As ever a project of this size dictates the assistance of numerous people behind the scenes, without whom this book would never have been possible.

A huge thank you to the people of Edinburgh who have approached me as I marched around the city, tripod in hand, and have shown great interest in the project and the logistics behind it. An extra special thank you to Vicky and Fanis for their wonderful inside city knowledge and for initially showing me some of the viewpoints photographed within this book.

Thank you once more to Steven Pugsley and the rest of the team at Halsgrove for making this book a reality. Yet again their support and flexibility has made this project, my fourth for Halsgrove, an absolute pleasure to work on.

The support of family and friends is an important element when I am working on a book so I would like to wholeheartedly thank all of you including John Friend, Penny, Roy and Mark Whitehouse, Valerie Hodgkins, Wayne Hackeson, Steve Hawthorne and Jason Haynes.

As ever my wife, Lynette, has been there to support and encourage me whenever I have most needed it. Thank you for all of your help and unconditional support.

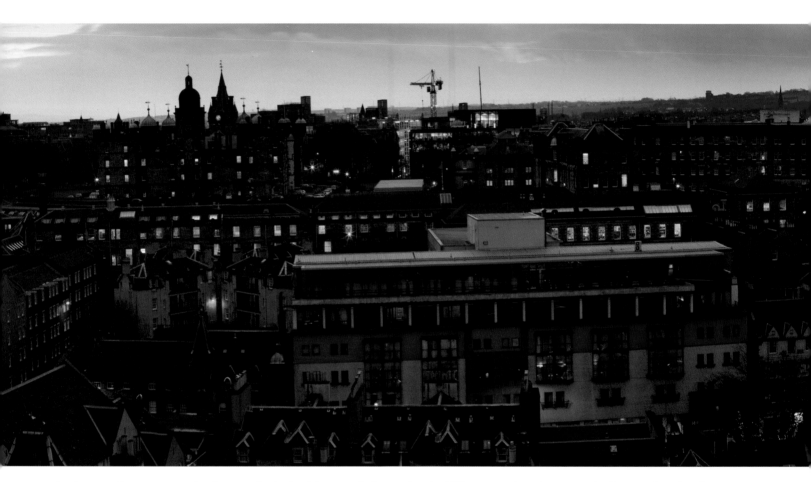

An impressive panoramic view at dusk, looking south from Castle Hill across the city towards the Pentland Hills.

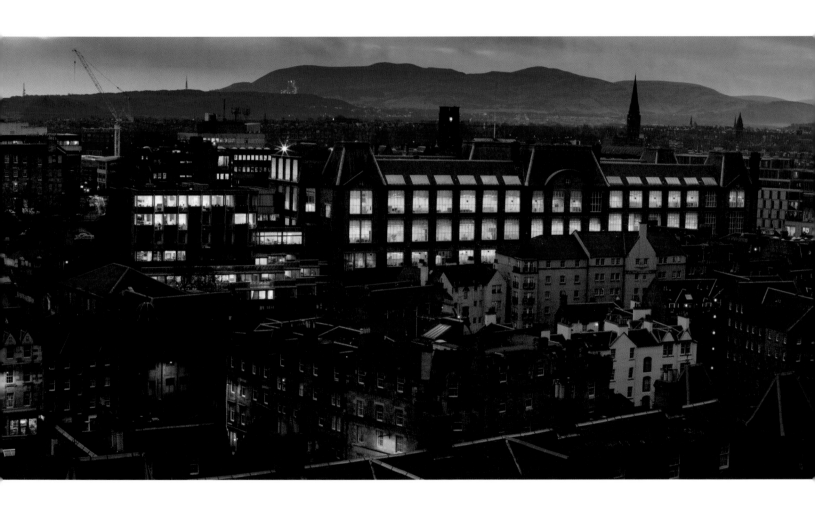

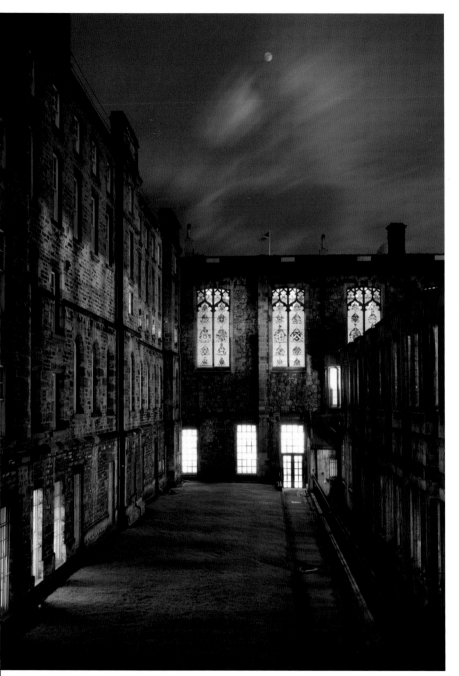

Left:
Courtyard viewed from the
George IV Bridge, which was
constructed to link the Old
and New Town.

Right:
Looking across New Town
to the River Forth.

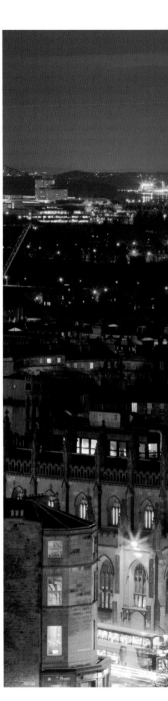

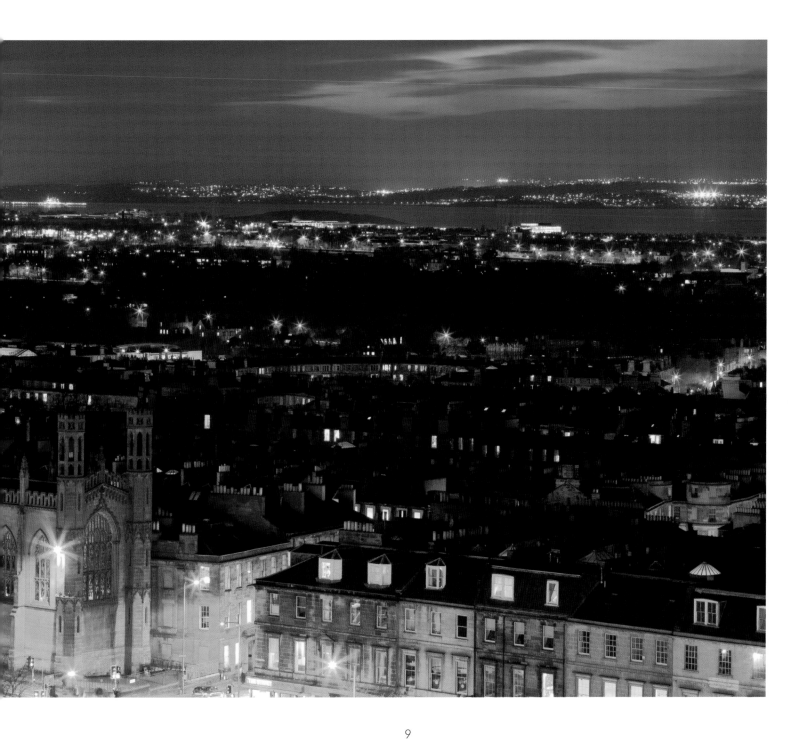

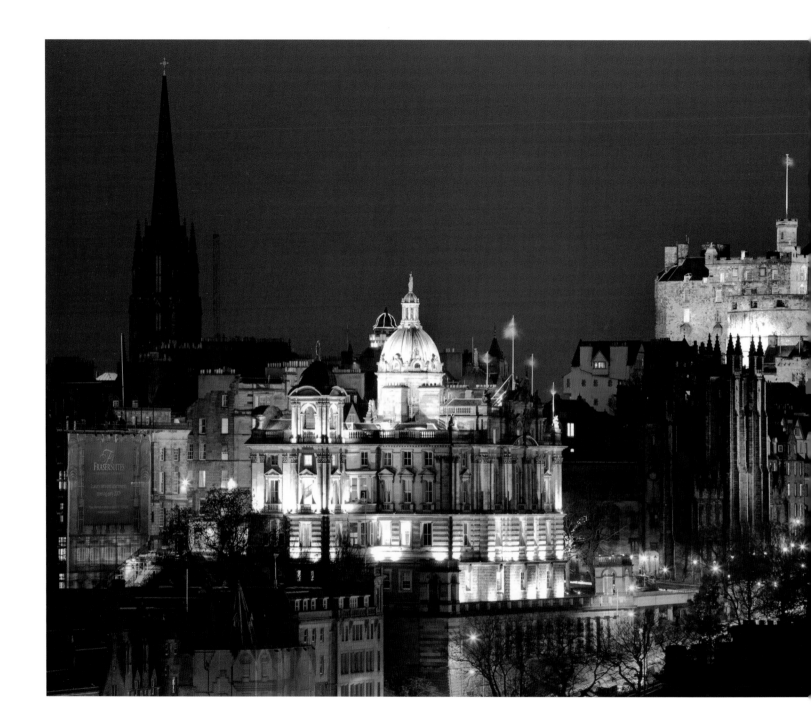

Left:
City skyline observed from the elevated position of Calton Hill, facing towards Castle Rock and the surrounding Old Town.

Right:
The skyline of Edinburgh city as seen from Calton Hill. The view is towards Princes Street and the Walter Scott Monument.

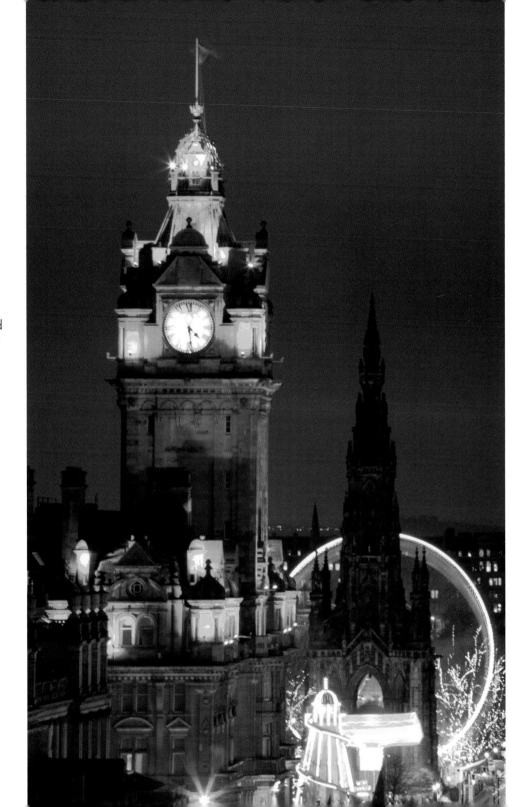

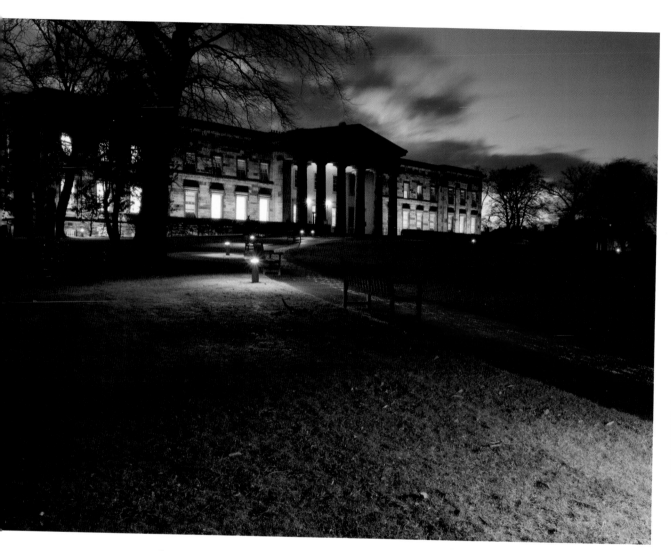

Flood-lit gardens at the Scottish National Gallery of Modern Art.

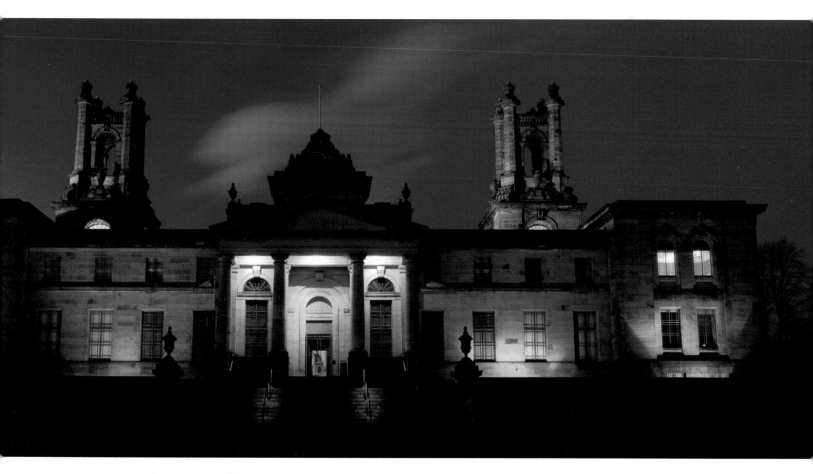

The Dean Gallery, part of the National Galleries of Scotland, opened in 1999 although the building was originally an orphanage designed by Thomas Hamilton.

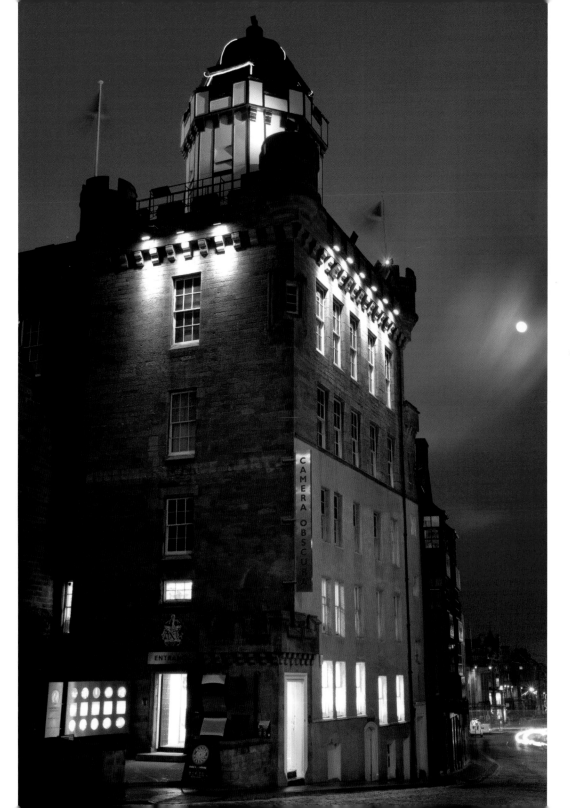

Left:
The Camera Obscura is located on a tower which had been the townhouse of the old Laird of Cockpen. This building was to become known as the Outlook Tower before its present title of the Camera Obscura.

Opposite:
The impressive building now known as the George Heriot's School on Lauriston Place in the Old Town, was established in 1628 as the George Heriot's Hospital with the aim of educating the poor children of the city.

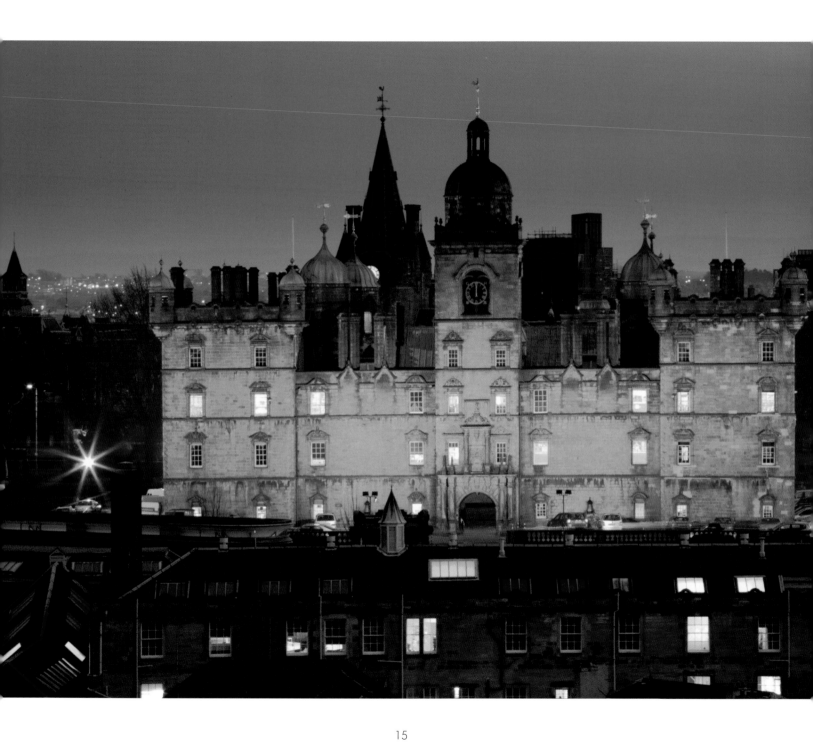

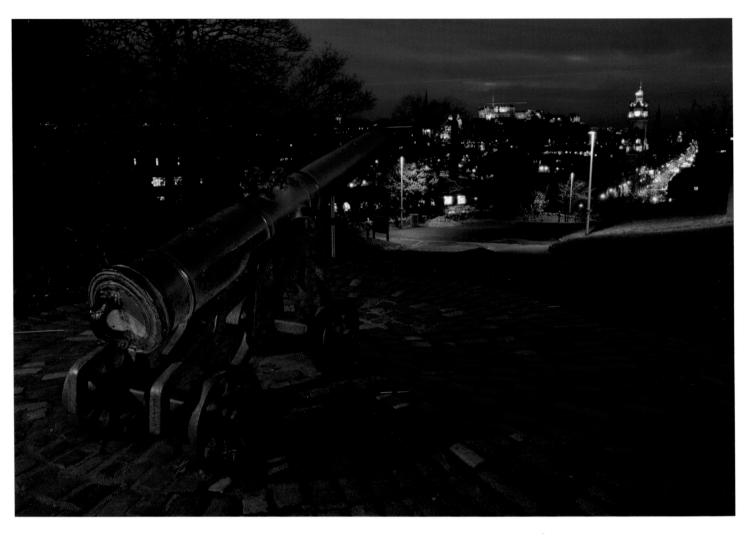

The Portuguese Cannon was captured by the British during the invasion of Burma in 1885. It was subsequently donated to the City of Edinburgh, and was placed in its present location on Calton Hill in 1887.

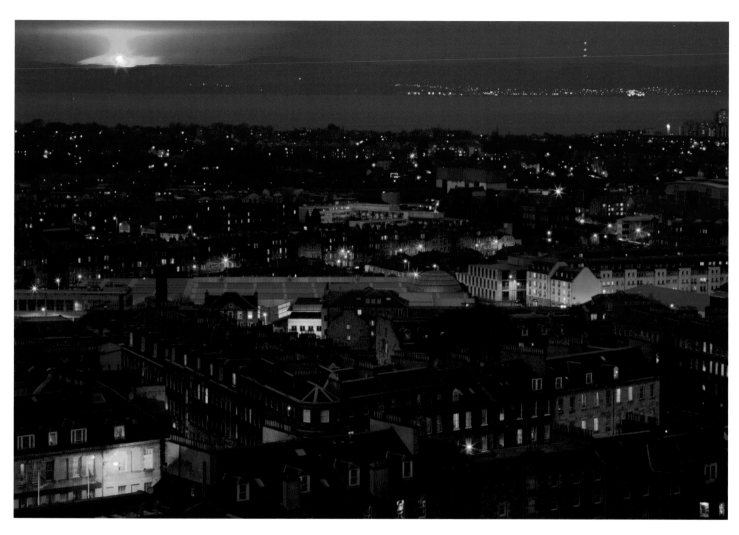

Edinburgh viewed from Calton Hill looking towards the River Forth.

The Cowgate, viewed from
the South Bridge.

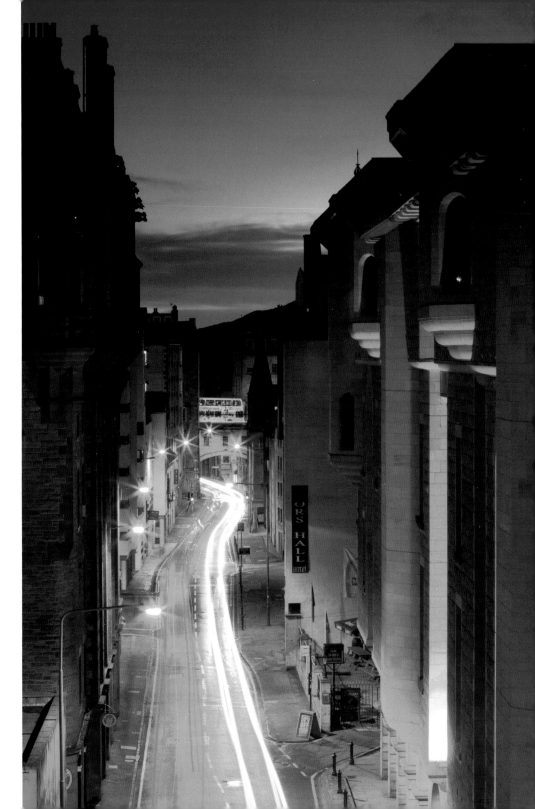

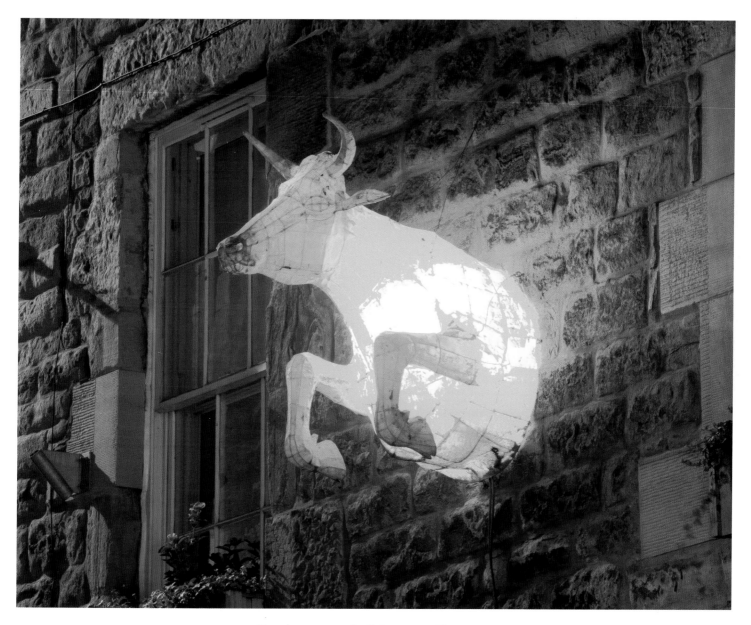

Cow lamp on a building near Cowgate.

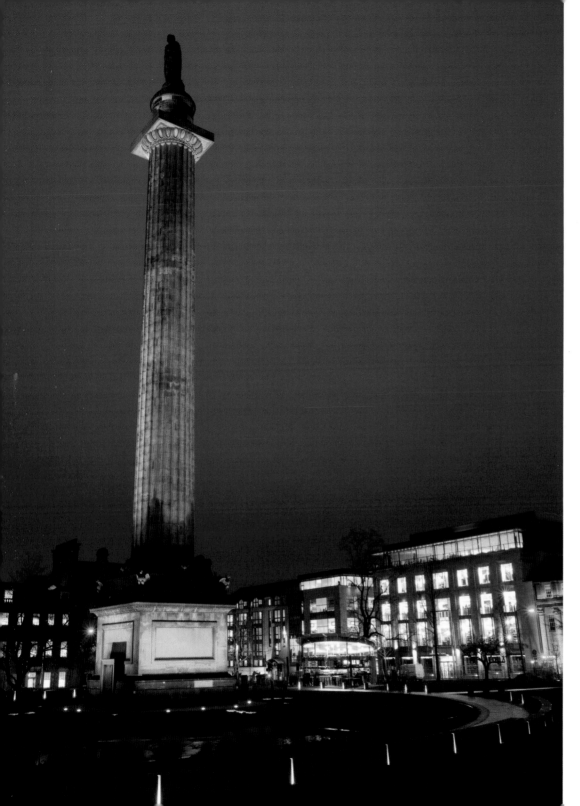

Erected in 1823 in honour of Henry Dundas, the Melville Monument stands proud in St Andrew's Square. The statue depicts Dundas looking towards George Street.

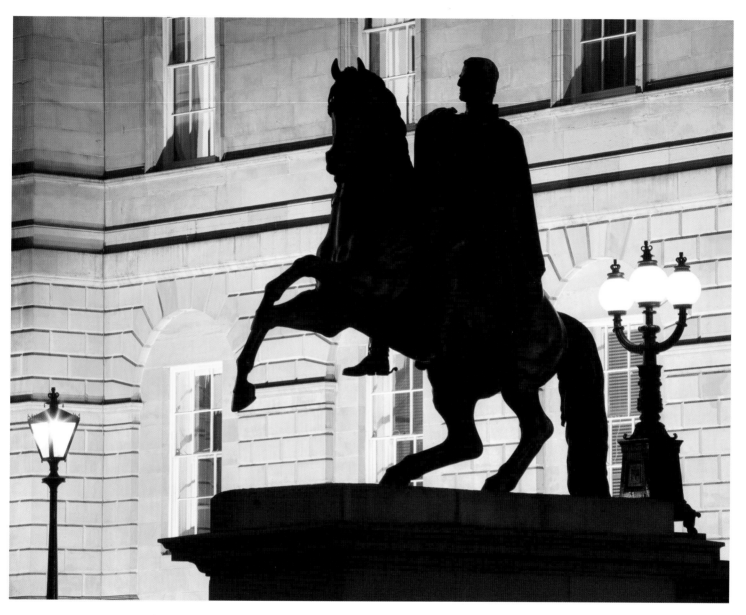

Statue of the Duke of Wellington on horseback situated in the front of the Register House.

Princes Street Gardens were created in the 1820s when the Nor Loch was drained.

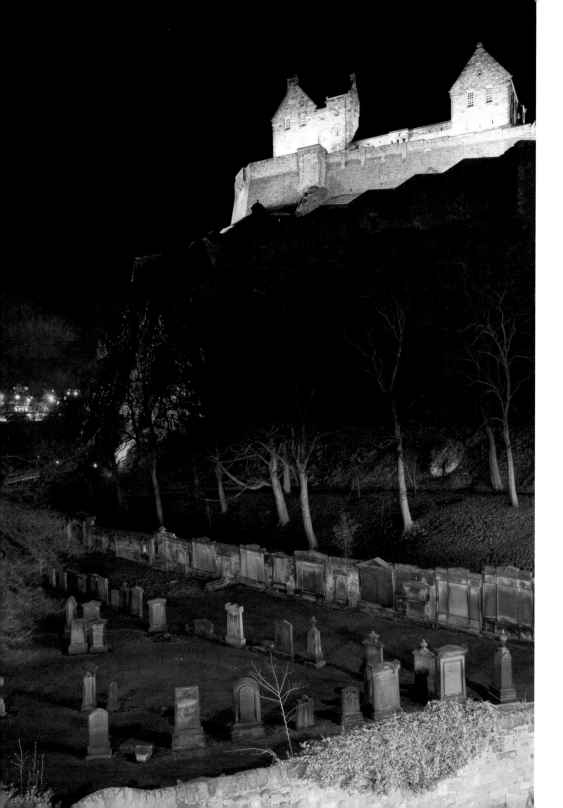

Edinburgh Castle high on Castle Rock, overlooking the graveyard of Saint Cuthbert's.

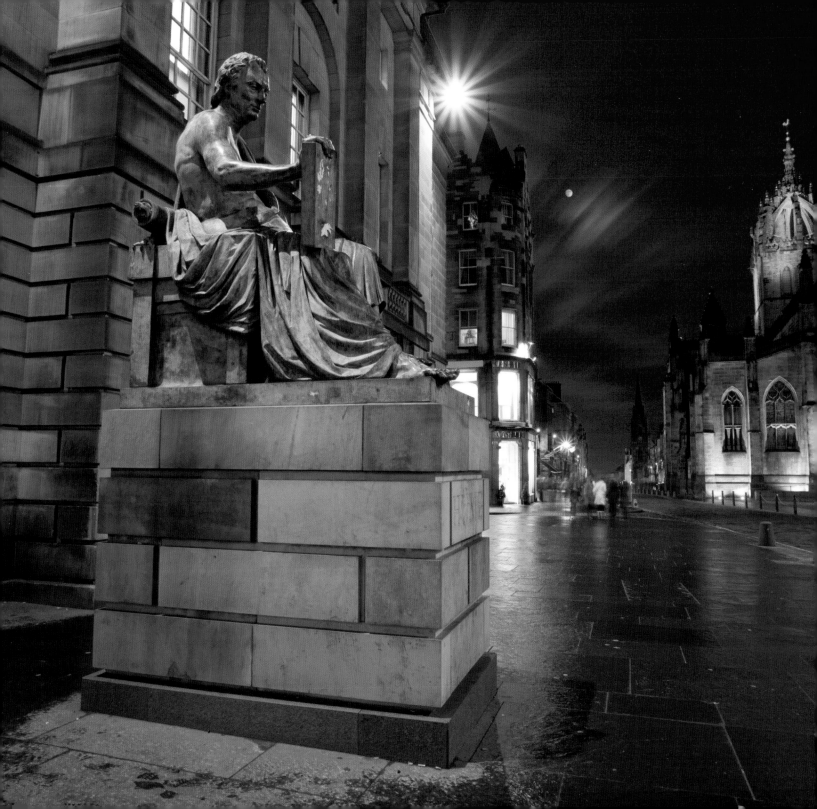

Left:
Hume statue in the foreground with St Giles' Cathedral to the right, situated along the Royal Mile.

Right:
Statue of Adam Smith, considered by many to be the father of modern economics, looking towards his home town of Kirkcaldy across the River Forth.

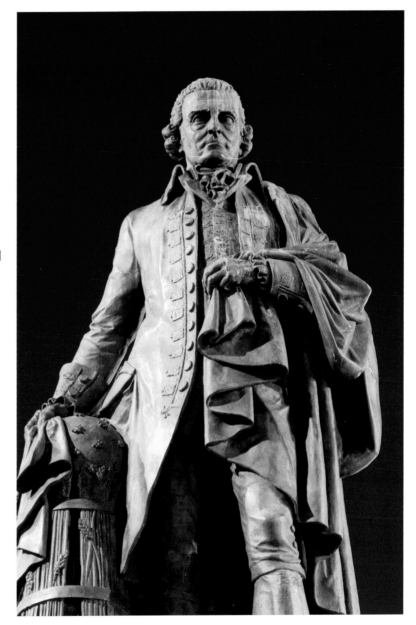

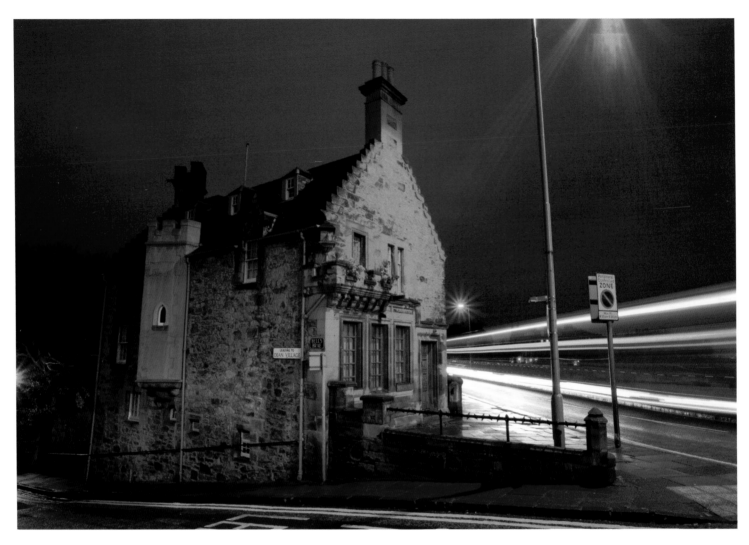

Old house on Dean Bridge. The Dean Bridge, designed by Thomas Telford, was opened in 1833 to carry the Queensferry Road over the Dean Gorge.

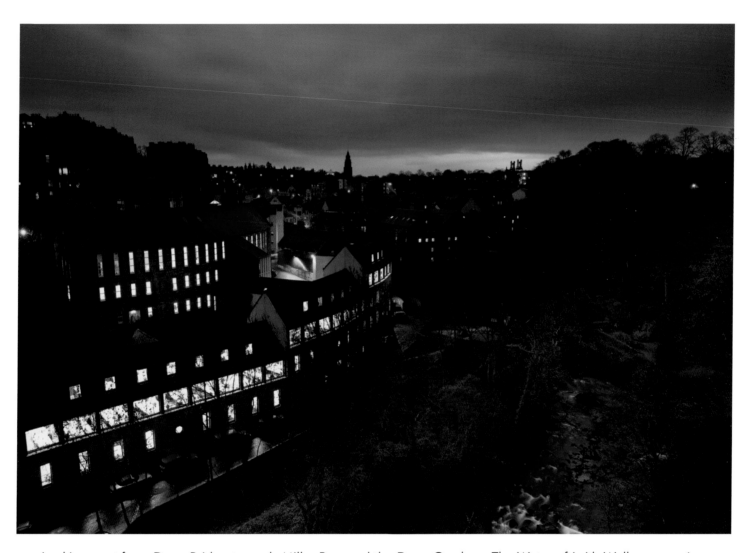

Looking west from Dean Bridge towards Miller Row and the Dean Gardens. The Water of Leith Walkway running alongside the river is a popular 12.25 mile walk stretching from Balerno to Leith.

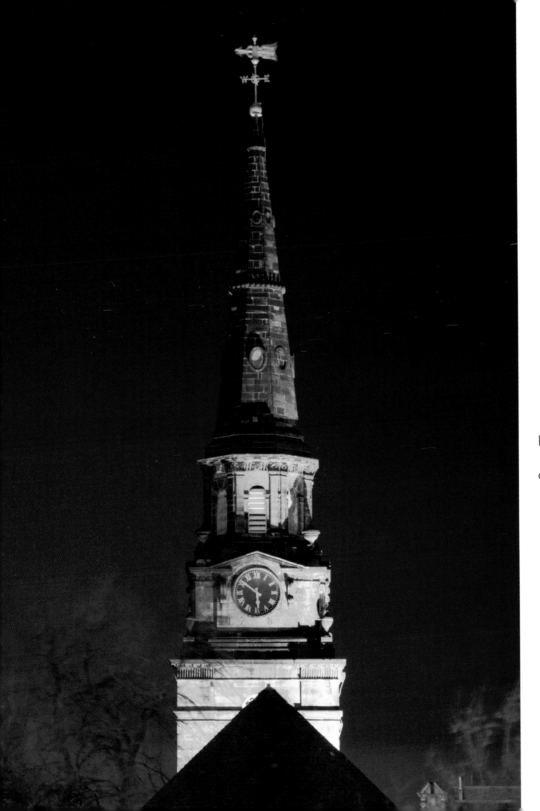

Left:
Spire of the Church of St John the Evangelist.

Right:
Statue of Sir John Hope, the 4th Earl of Hopetoun, a noted soldier born at Hopetoun House in Edinburgh. The statue is located in front of Dundas House, the registered office of the Royal Bank of Scotland of which Hope had been a governor.

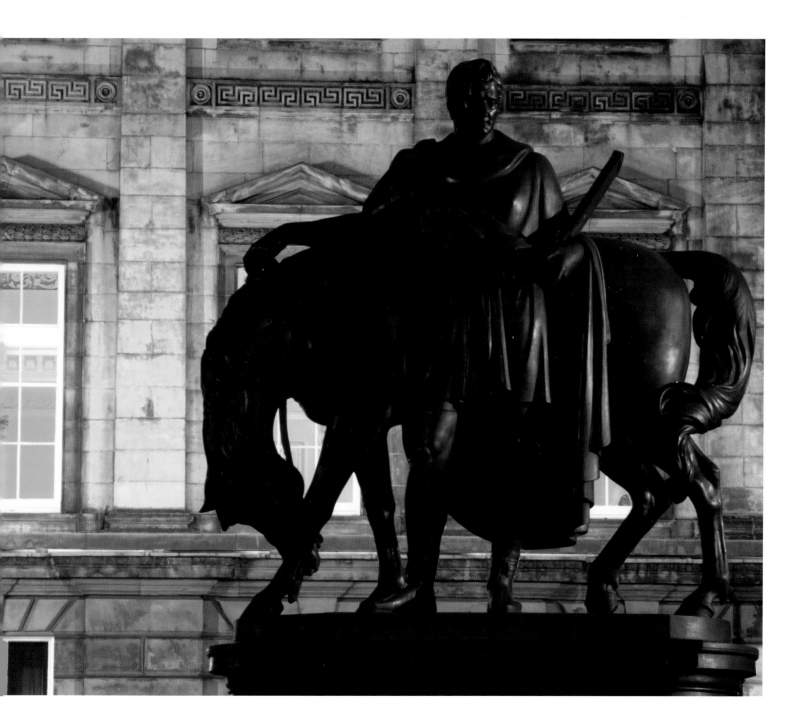

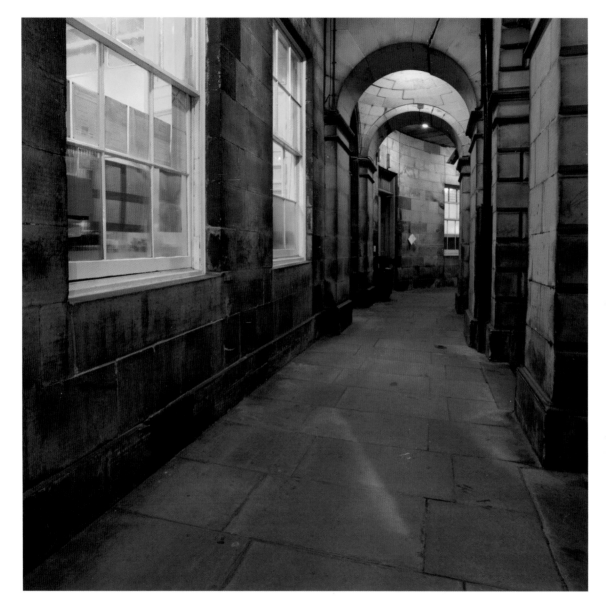

Right:
The Assembly Rooms and Music Hall located on George Street. Assembly Rooms were traditionally gathering places open to members of both sexes from the higher social classes. Between the eighteenth and nineteenth centuries this was quite unusual with most venues only being open to upper class men.

Covered walkway at Parliament House, originally home of the Scottish Parliament but now host to the Supreme Courts of Scotland.

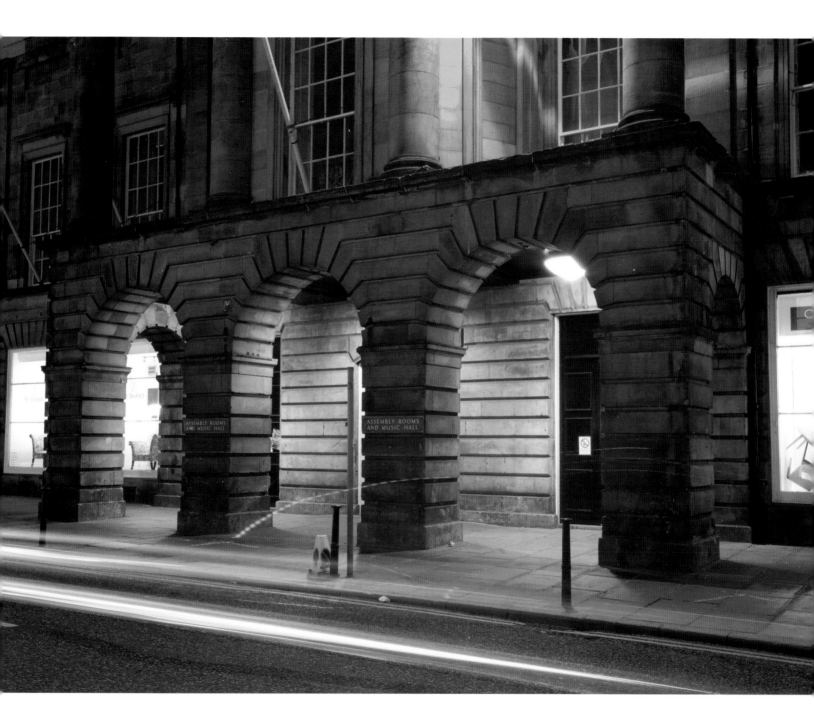

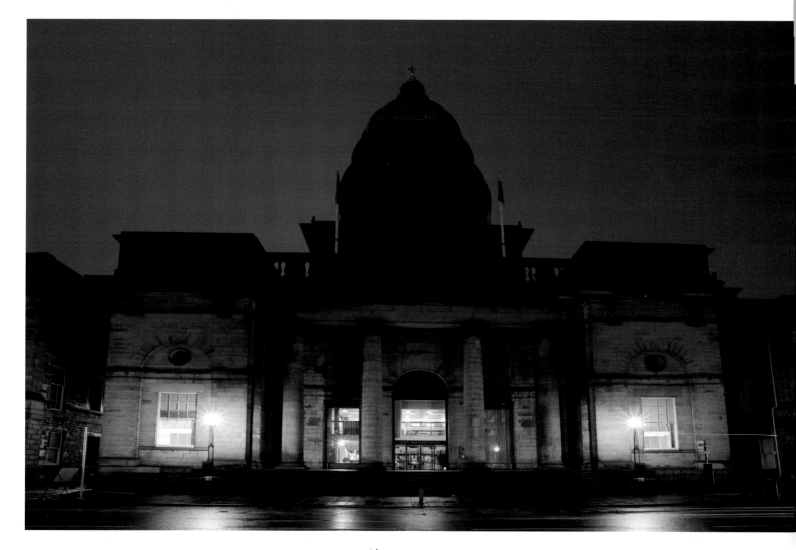

Above:
Originally opened as a church in 1814, the West Register House became a branch
of the Scottish Record Office in 1968.

Left:
The Camera Obscura with The Hub in the background. The Hub was originally known as the Victoria Hall and this
historic landmark found along the Royal Mile is a Grade A listed building constructed between 1842 and 1845.

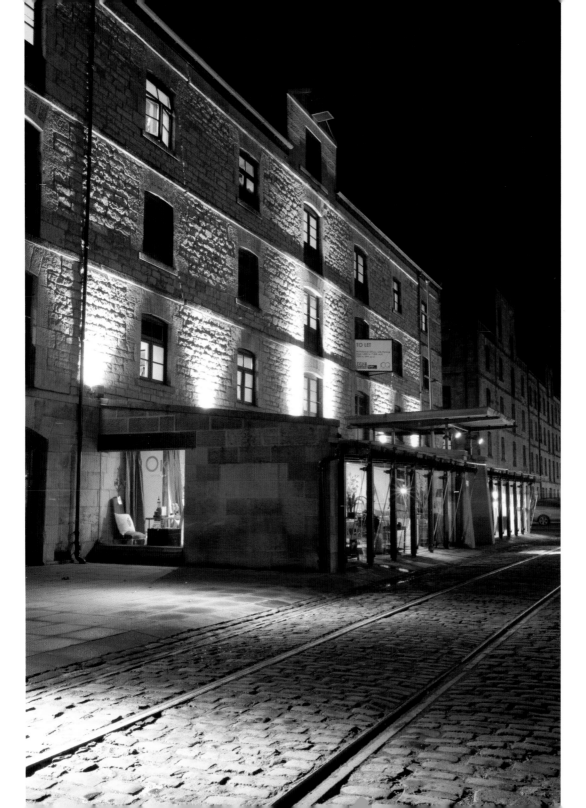

Cobbled pedestrian
walkway on the Leith
Commercial Quay.

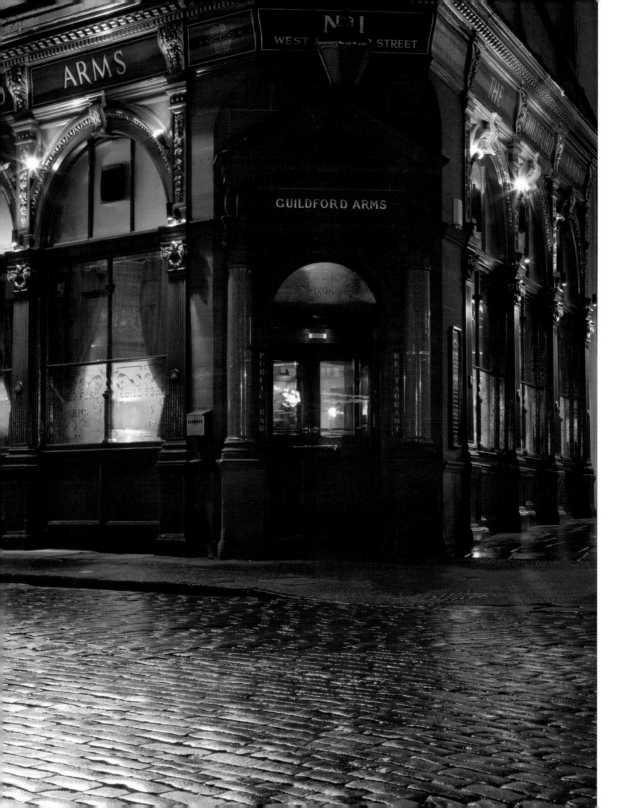

The Guildford Arms on West Register Street, built in 1898 to a design by Robert Macfarlane Cameron.

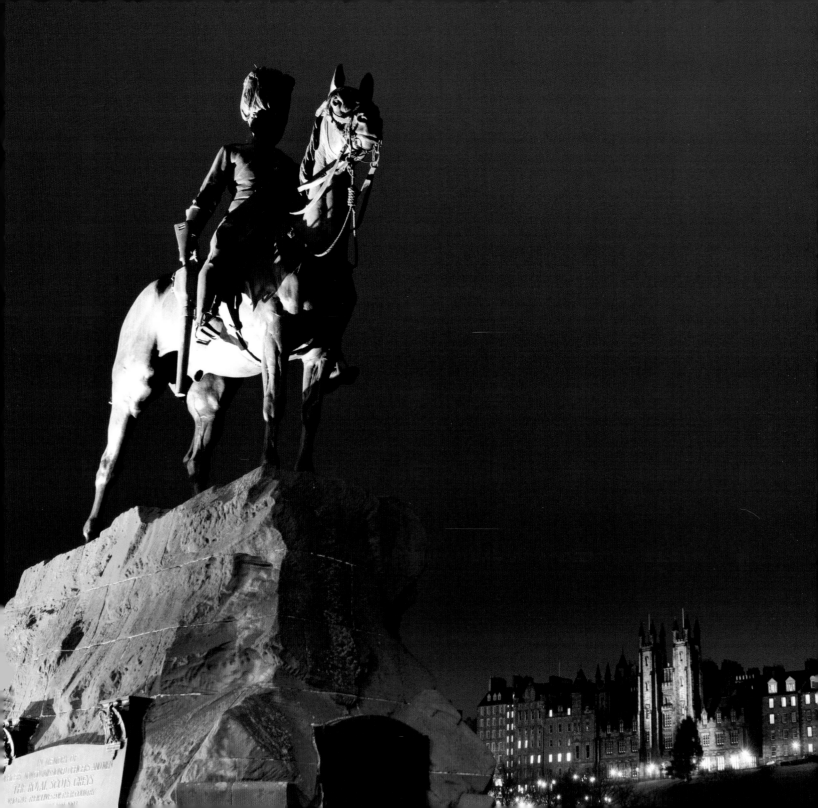

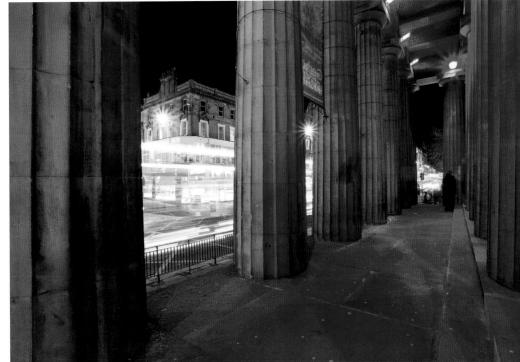

Above:
Illuminated façade of the Royal Scottish Academy
on the busy Princes Street.

Opposite:
Monument on Princes Street erected in memory of the
Royal Scots Greys who died for their country
during the Boer War (1899–1902).

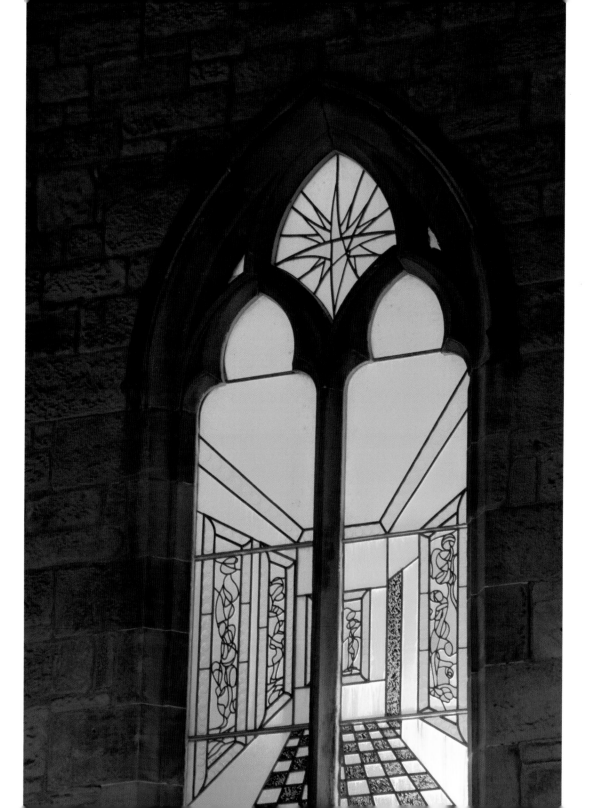

Unusual stained glass window on the Queen's Gallery Building.

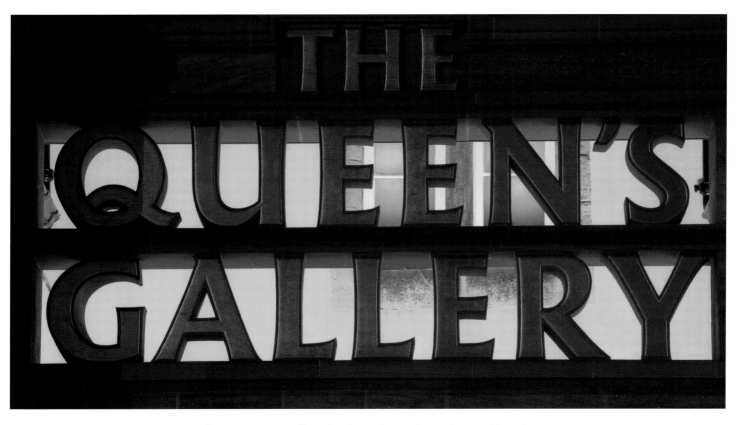

The Queen's Gallery, built as the Holyrood Free Church,
which forms part of the Palace of Holyroodhouse complex.

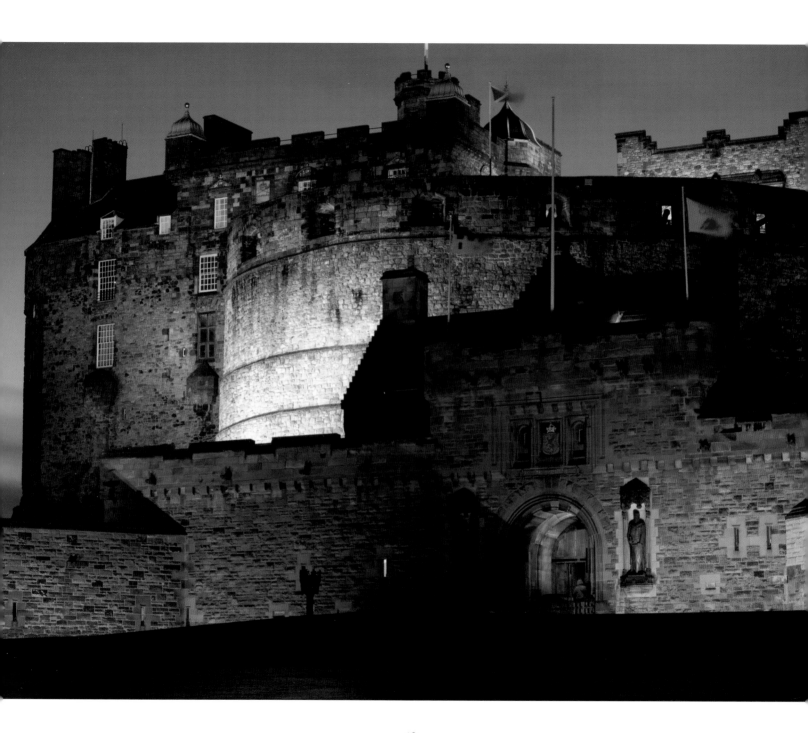

Opposite:
Edinburgh Castle dominates the
Edinburgh skyline as a result of its
elevated position on Castle Rock.
In order to fully appreciate its
architecture, it is essential that
it is viewed in close proximity
from the Castle Esplanade.

Right:
Sir William Wallace statue,
a famous leader during the
First War of Scottish Independence,
situated at the entrance to
Edinburgh Castle.

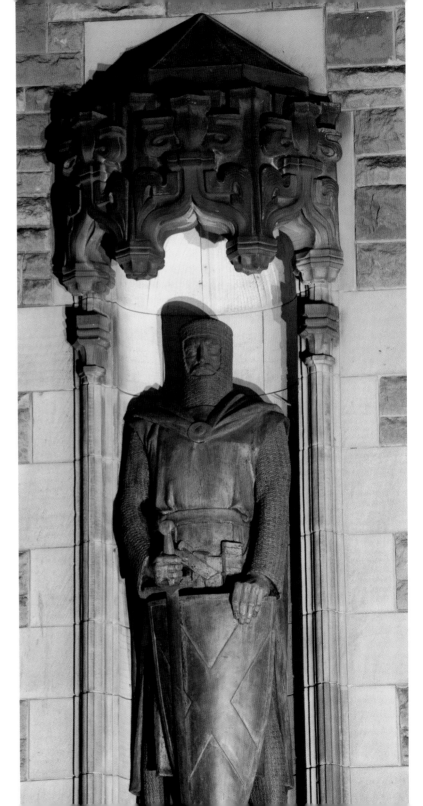

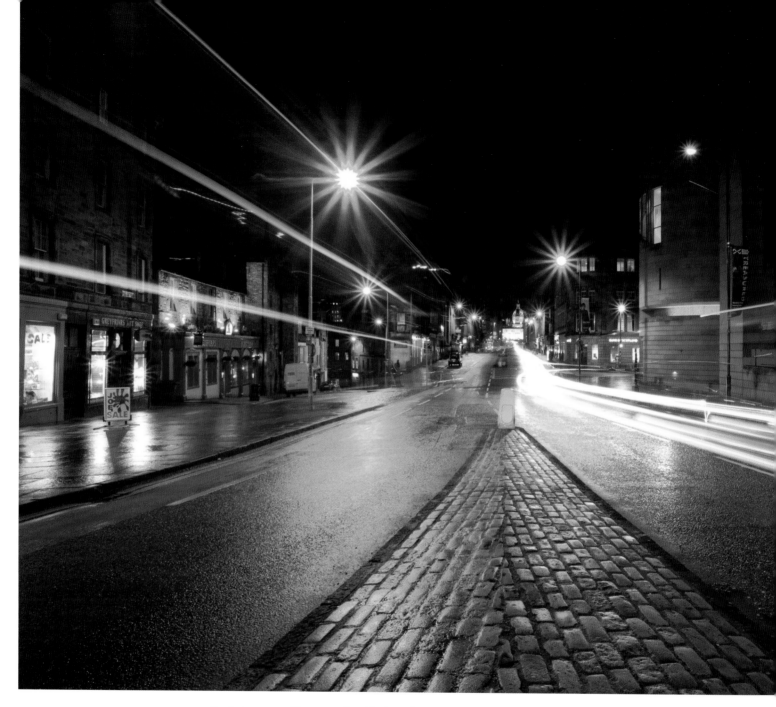

Rush hour traffic near the National Museum of Scotland.

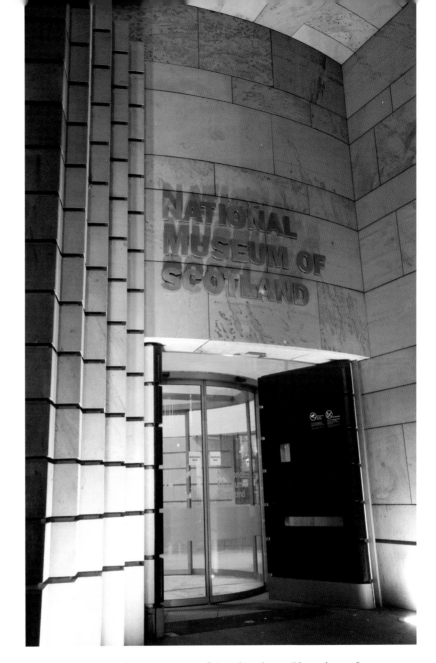

Entrance to the Museum of Scotland on Chambers Street. The appearance of the building is a controversial issue, with Prince Charles resigning as patron of the museum due to a lack of public consultation regarding the design.

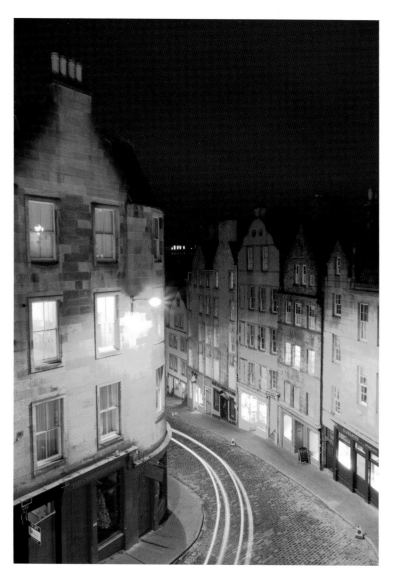

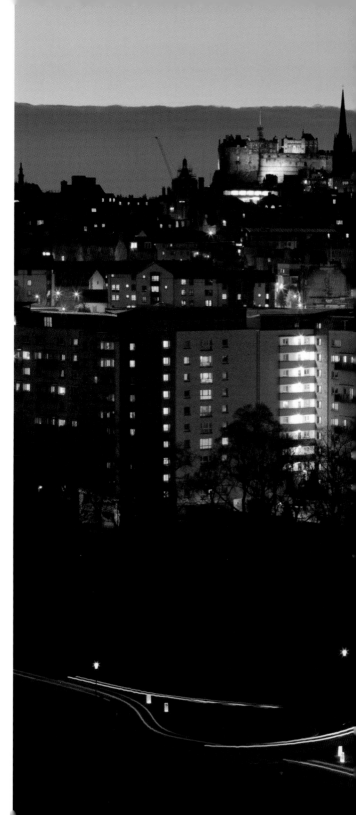

Above:
The street of West Bow in the Old Town.

Right:
Looking towards the Old Town and the city centre from an elevated viewpoint near Arthur's Seat in the Holyrood Park.

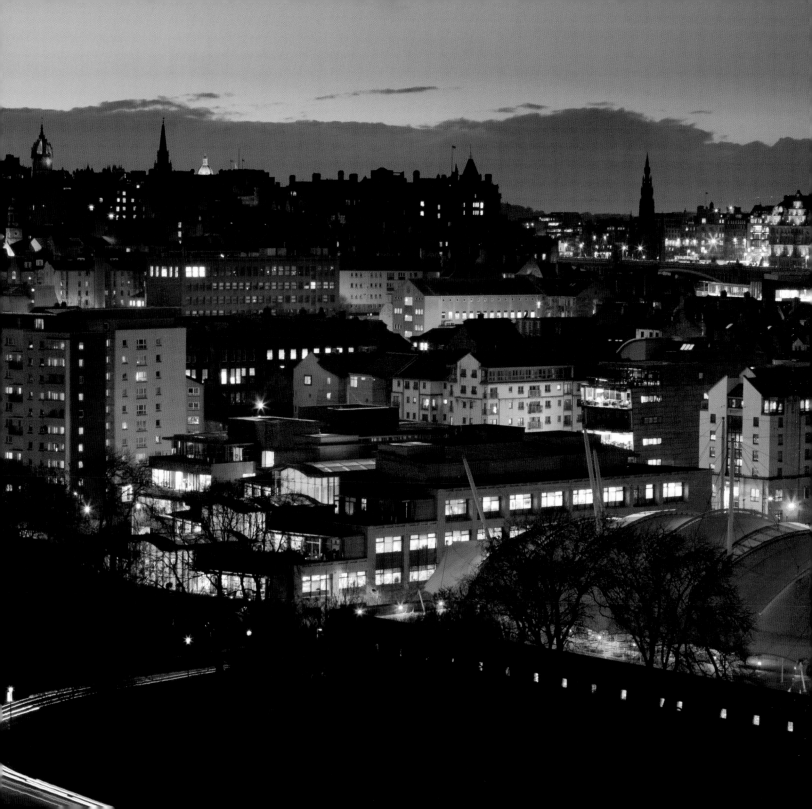

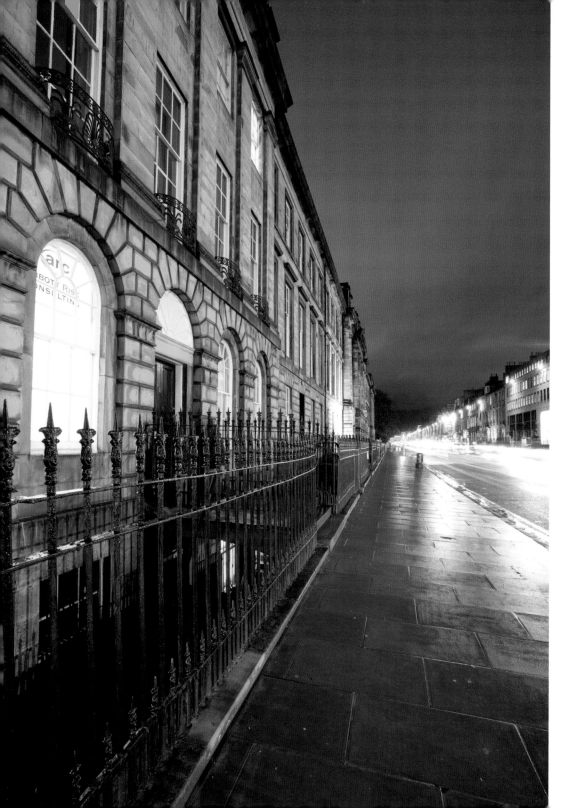

Albyn Place, with Queen Street and the Queen Street Gardens in the distance.

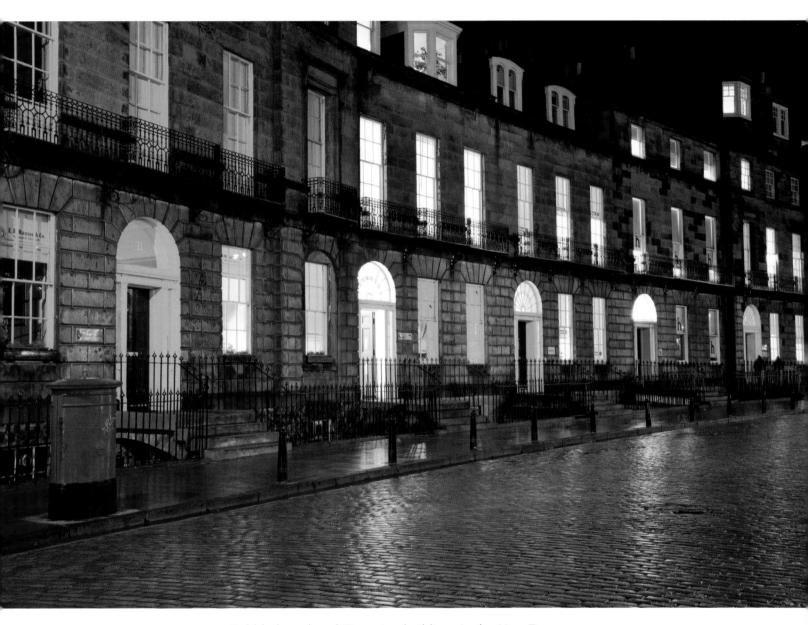

Cobbled road and Georgian buildings in the New Town.

A Ferris wheel forming part of the city Christmas fair held near the Scott Monument in East Princes Street Gardens.

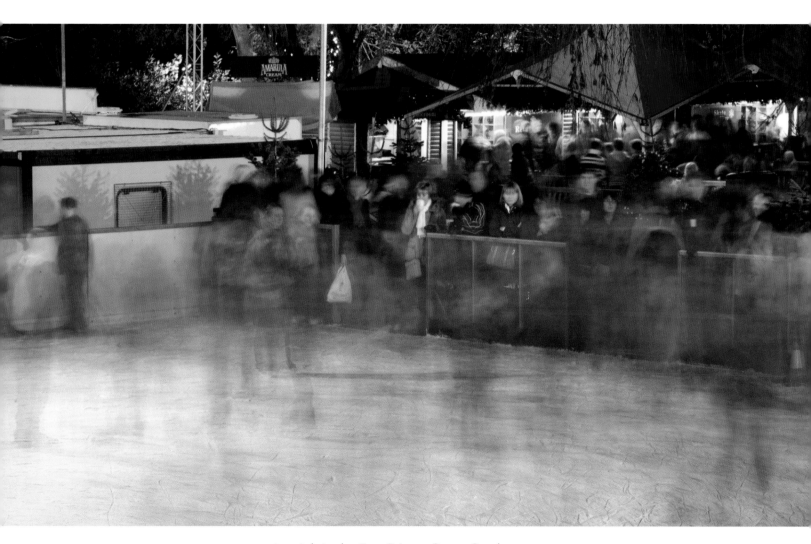

Ice rink in the East Princes Street Gardens.

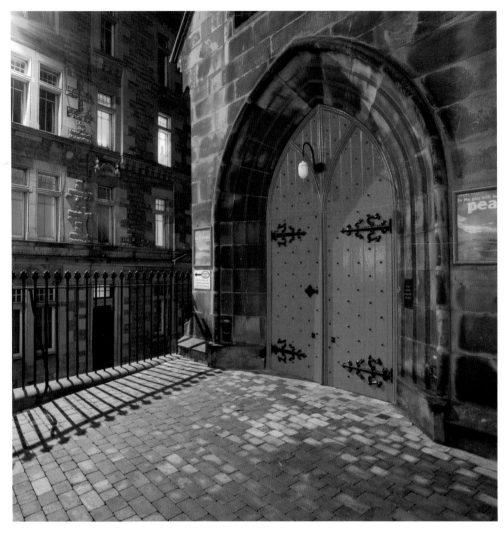

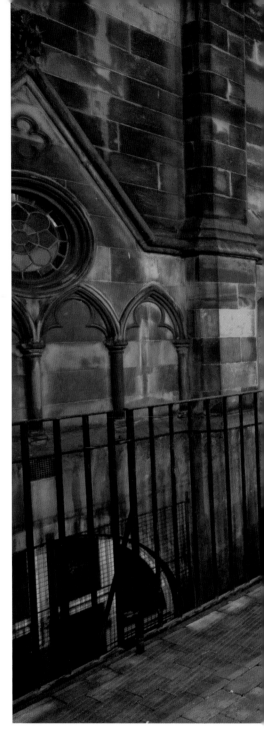

Above:
Courtyard and doorway of St Columba's Church,
known to many as St Columba's by the Castle.

Right:
St Columba's Church, The Hub and Johnstone Terrace,
near the Castle and the Royal Mile.

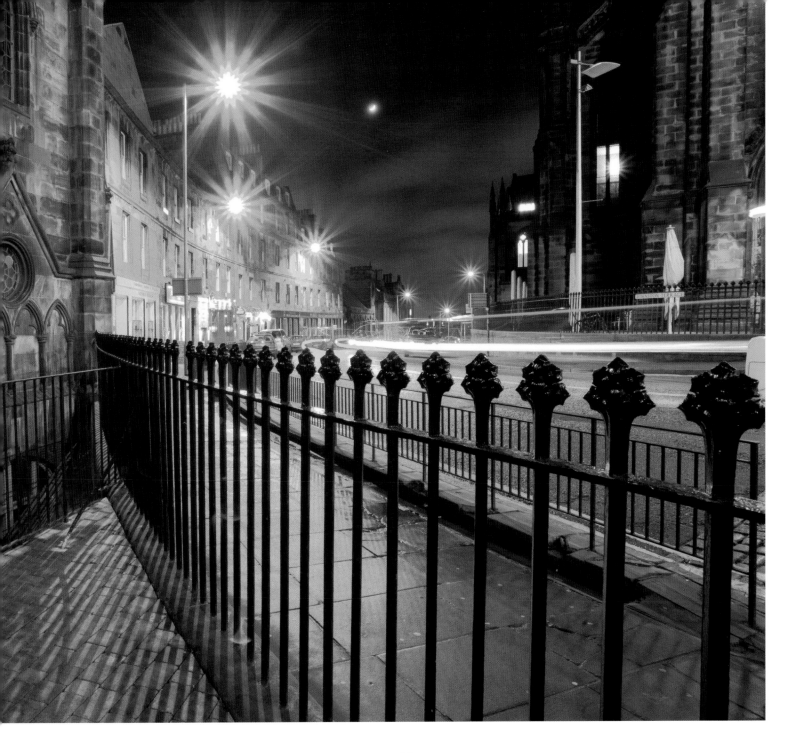

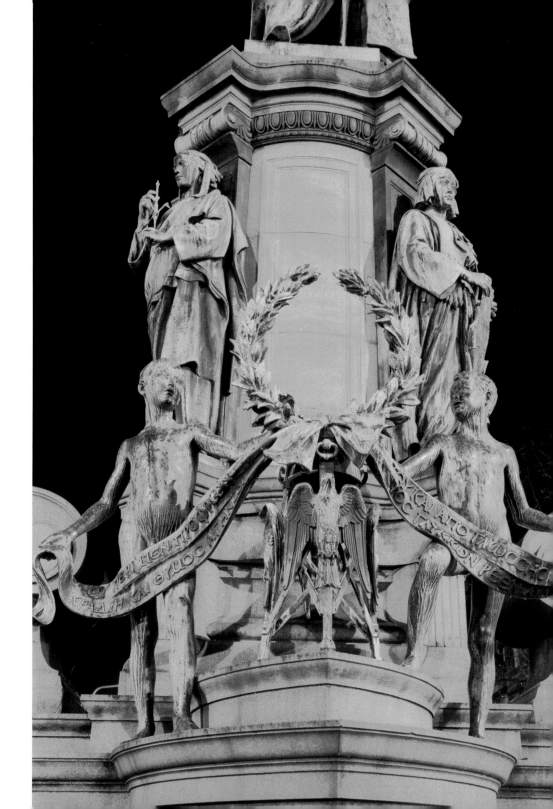

Sculpture by J. Pittendrigh
McGillvray near Coates Crescent
in the New Town.

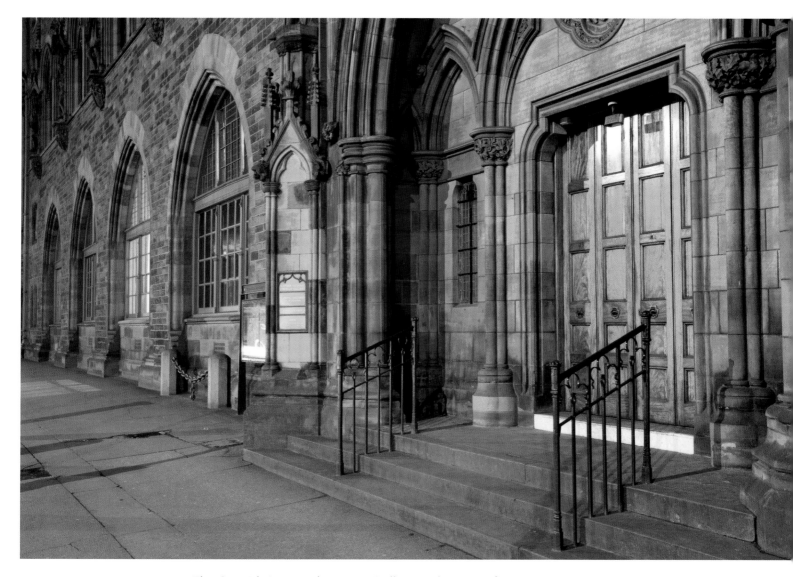

The Scottish National Portrait Gallery at the time of construction
was the world's first purpose-built portrait gallery.

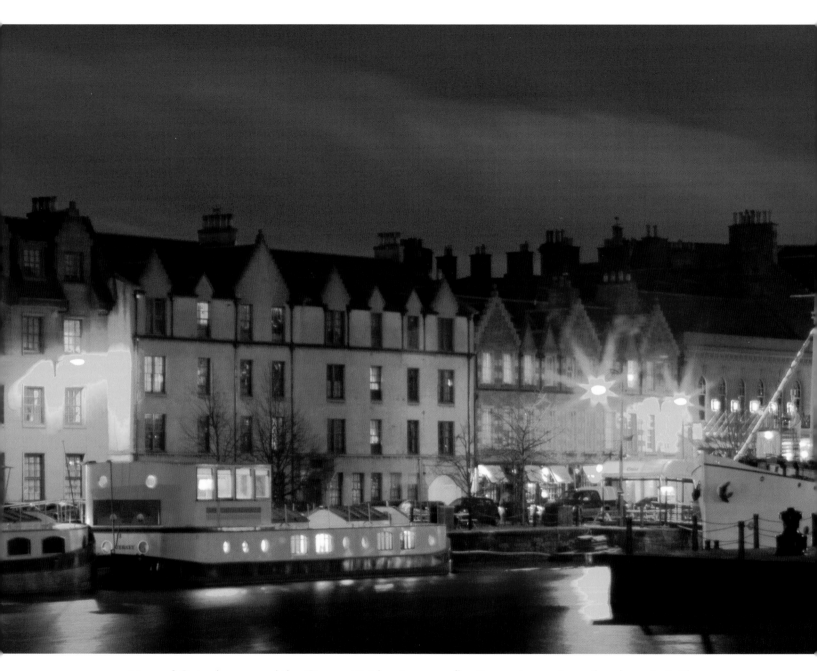

Mary of Guise barge and the *Ocean Mist* boat, now a floating restaurant, on the shore in Leith.

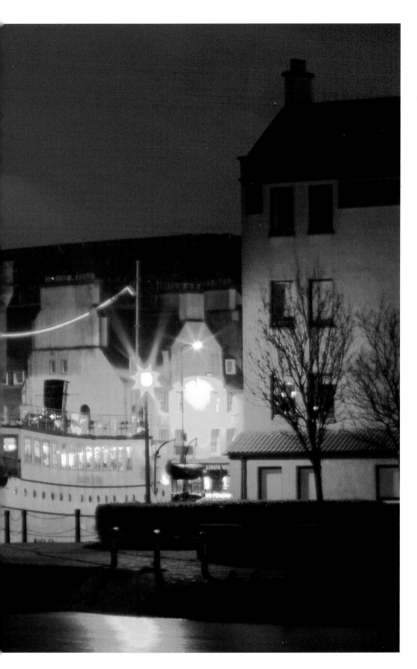

Fish and boat sculpture near the entrance to
the Leith Commercial Quay.

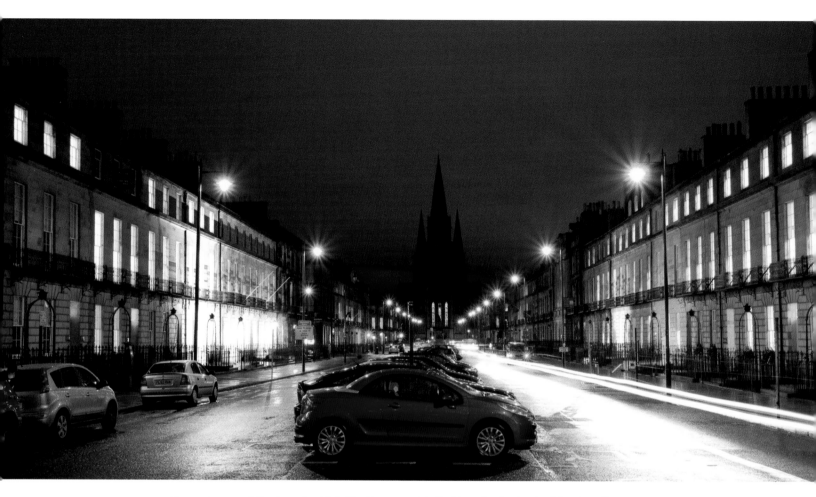

Georgian architecture in Melville Street, with St Mary's Cathedral in the distance.

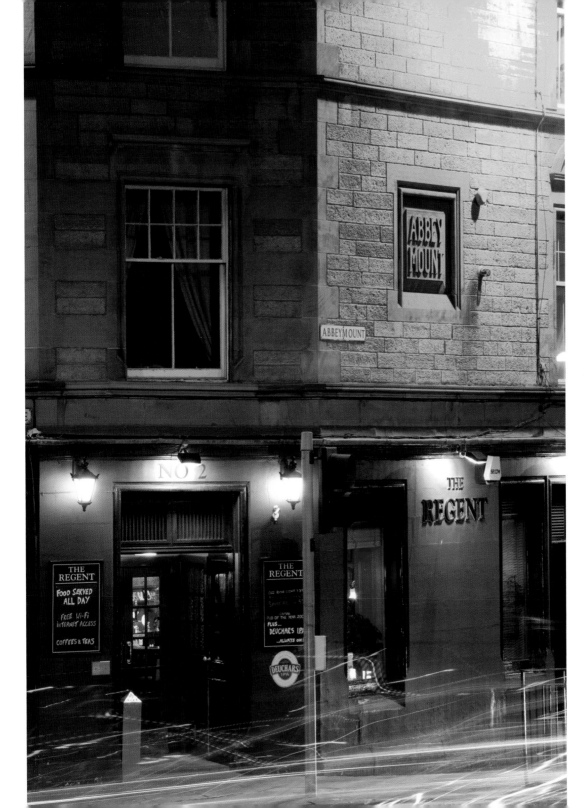

The Regent Public House
on Abbey Mount.

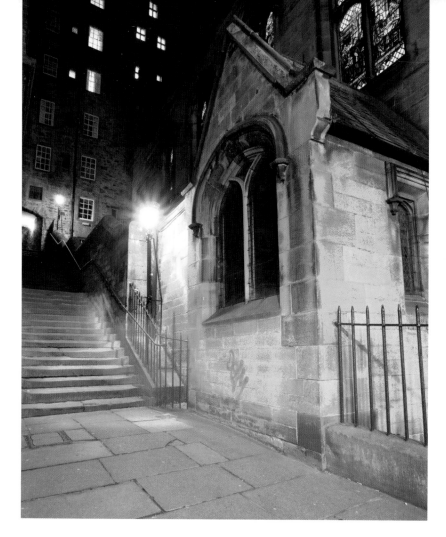

Above:
Milne's Court, a narrow passageway heading to the Royal Mile, alongside the New College.

Right:
The New College and Assembly Hall on the Mound were opened in 1846 as the Free Church of Scotland New College. More recently the Assembly Hall has been used as a debating chamber for the Scottish Parliament prior to the construction of the new Parliament Building at Holyrood.

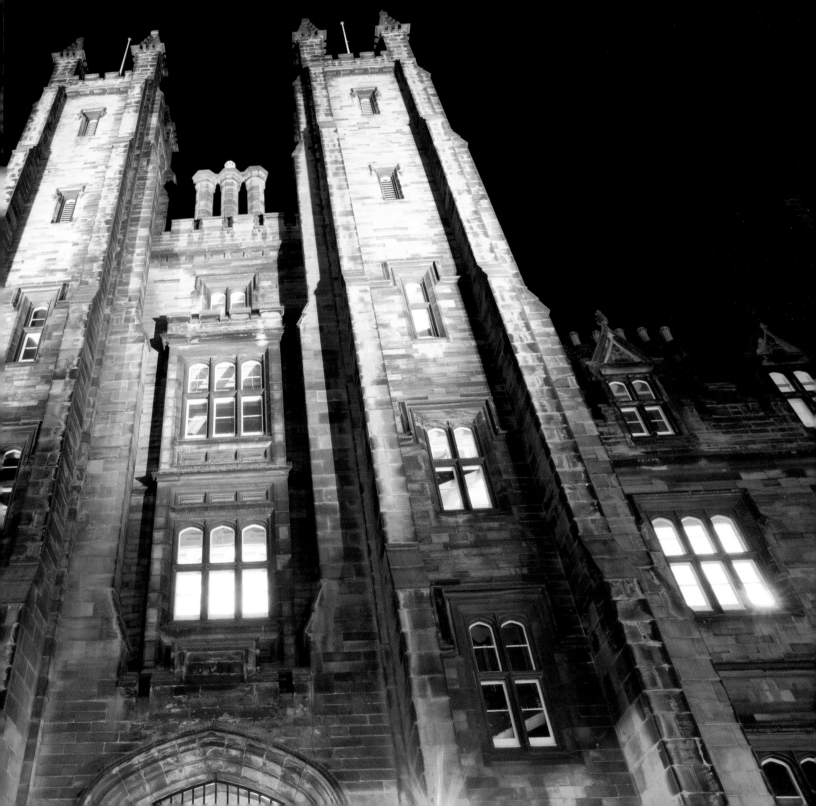

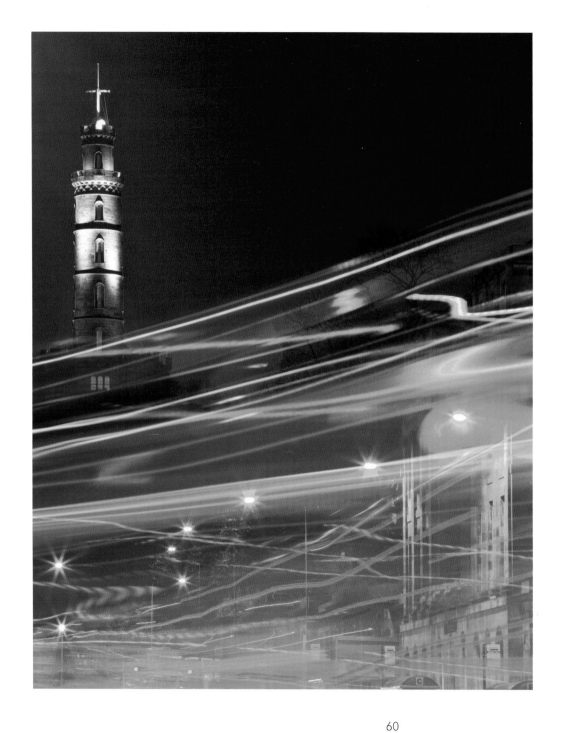

Left:
Busy traffic along
Waterloo Place, overlooked
by the Nelson Monument.

Right:
Rush-hour traffic on
Hanover Street.

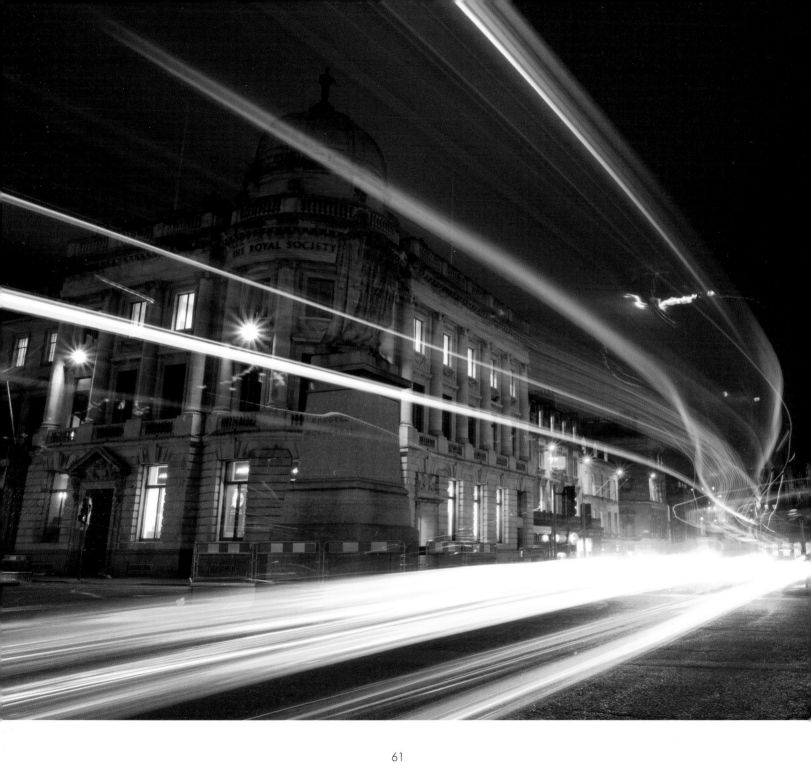

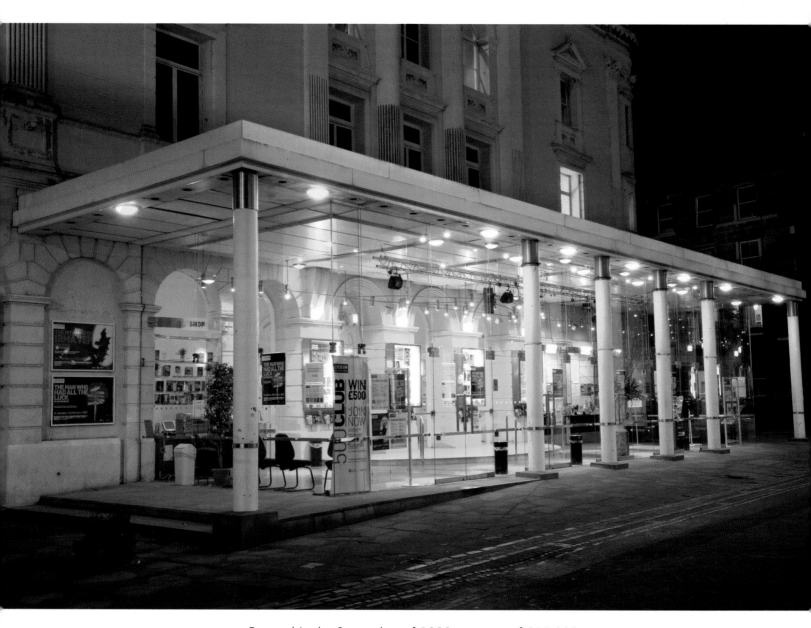

Opened in the September of 1883 at a cost of £17,000,
the glass foyer pictured here was added to the Royal Lyceum Theatre in 1991.

Scottish Executive building in Leith, standing on reclaimed ground which was previously docks.

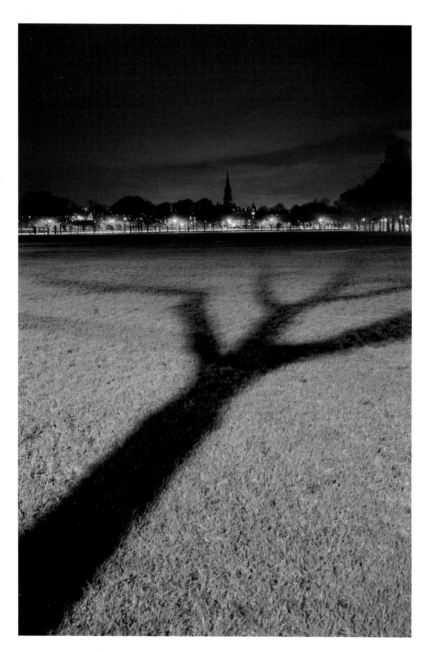

Dean Cemetery stands on
the former site of
Dean House which was
demolished in 1845.

Originally a loch, the Meadows is now a large expanse
of open greenery found near the centre of the city.

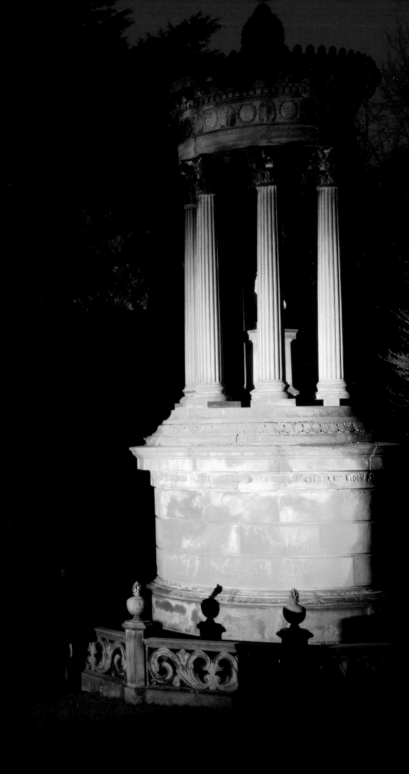

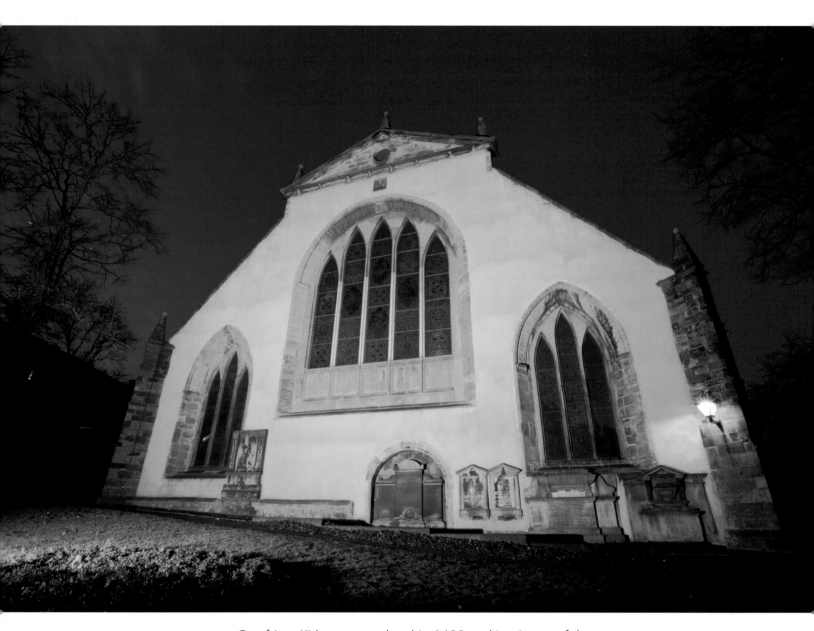

Greyfriars Kirk was completed in 1620 making it one of the
oldest surviving buildings outside of the Old Town.

Greyfriars Bobby, the famous loyal Skye Terrier, who lay on the grave of his master John Gray for 14 years after his death in 1858 – only leaving his grave briefly to find food.

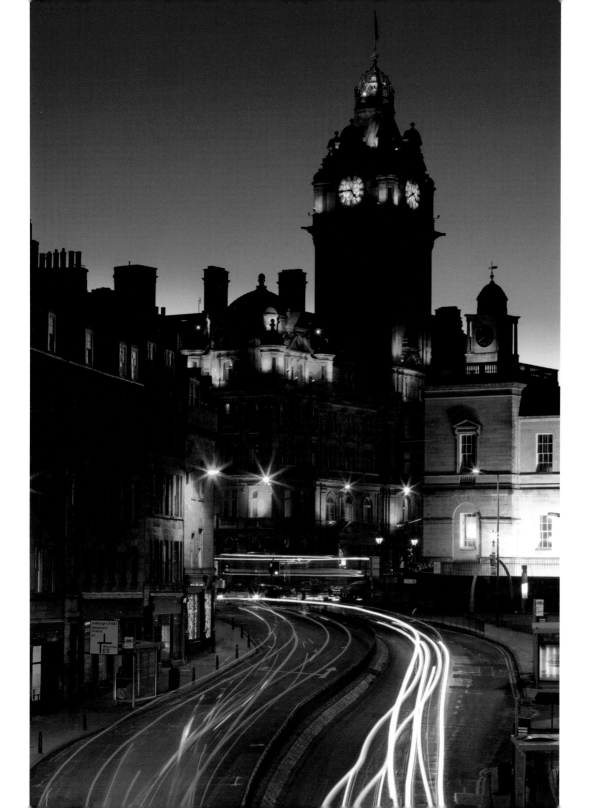

Rush hour traffic on
Leith Street near the
Balmoral Hotel and
the Register House.

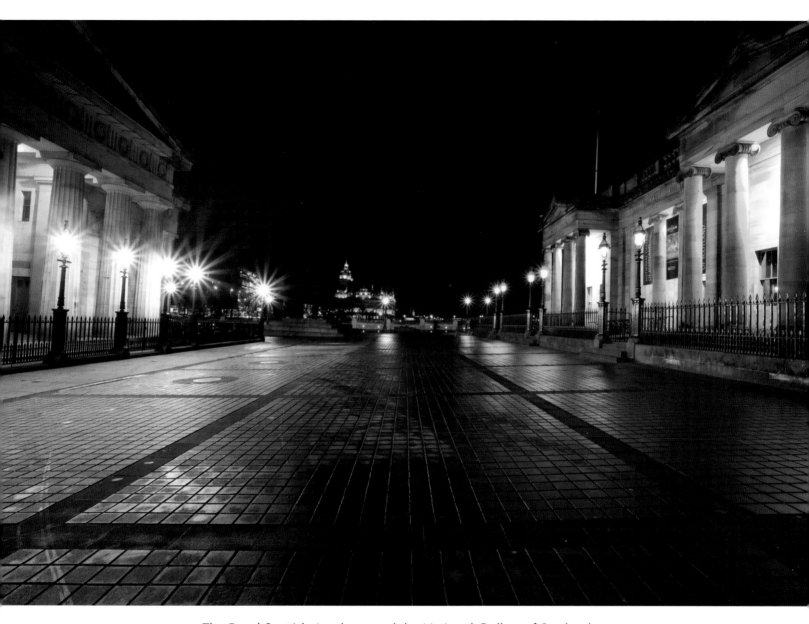

The Royal Scottish Academy and the National Gallery of Scotland.

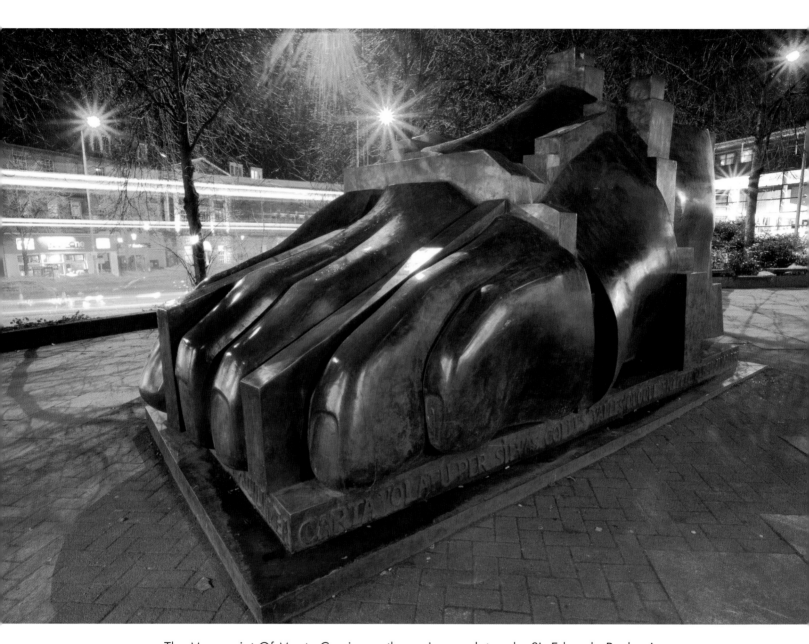

The Manuscript Of Monte Cassino, a three piece sculpture by Sir Eduardo Paolozzi
located outside St Mary's Roman Catholic Cathedral. Perhaps unsurprisingly,
this part of the sculpture is often referred to as the 'Big Foot'.

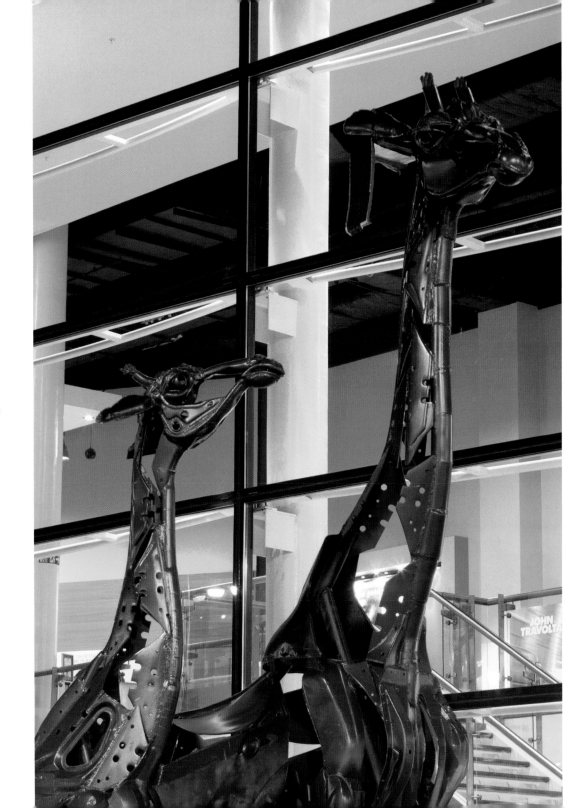

These two giraffes that stand proud outside the Omni situated at Greenside Place, were created entirely out of scrap metal. They were titled Dreaming Spires by their designer Helen Denerley.

Above:
The narrow Rose Street was originally used as a service entrance
to the houses on Princes Street and George Street.

Right:
Traffic on Northumberland Street. Edinburgh was originally part of the
Kingdom of Northumbria, an area that is now considered to consist of
North-East England but historically also included parts of Southern Scotland.

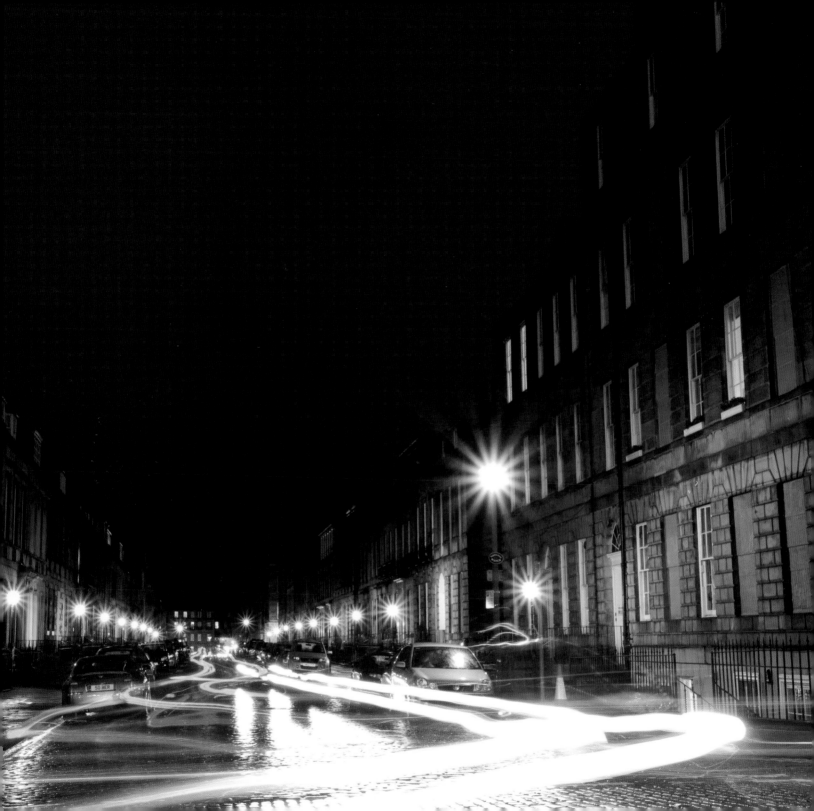

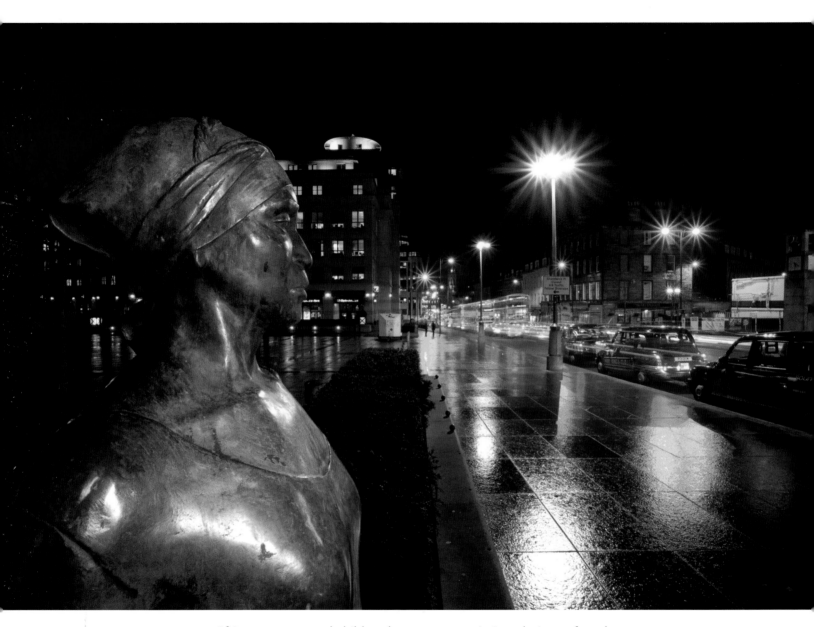

African woman and child sculpture, a commissioned piece of work
by Scottish sculptor and artist Anne Davidson, located on
the corner of Festival Square and Lothian Road.

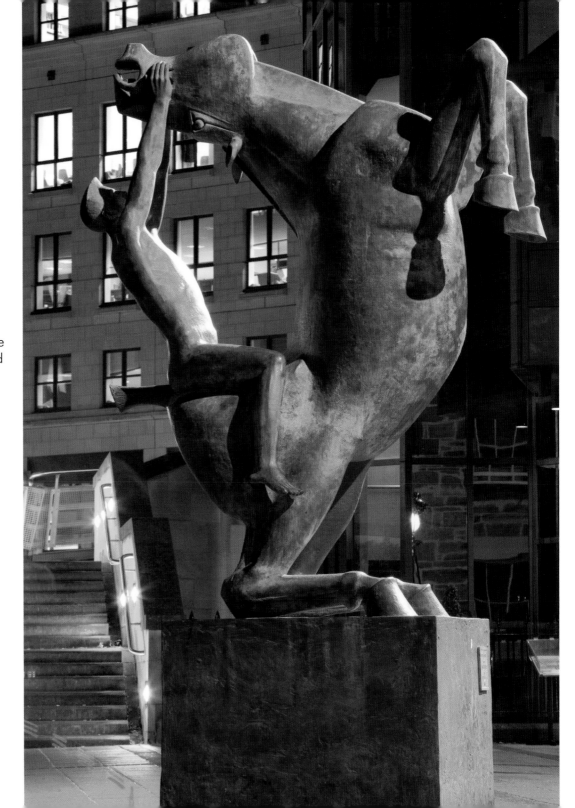

'Horse and Rider' sculpture by Eoghan Bridge, situated in Rutland Court.

75

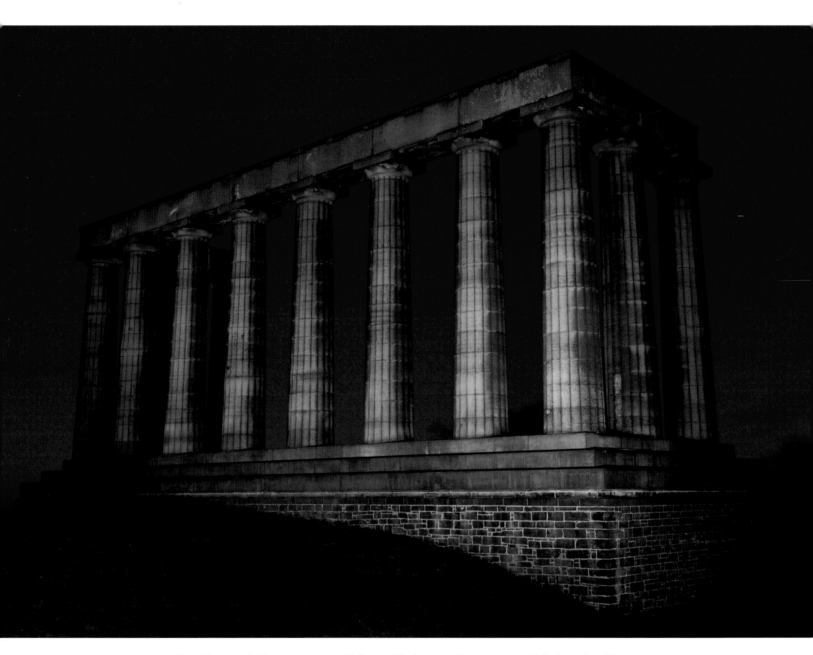

The National Monument on Calton Hill, known by many as Edinburgh's Disgrace
as it is considered to be an incomplete construction due to lack of available funds.

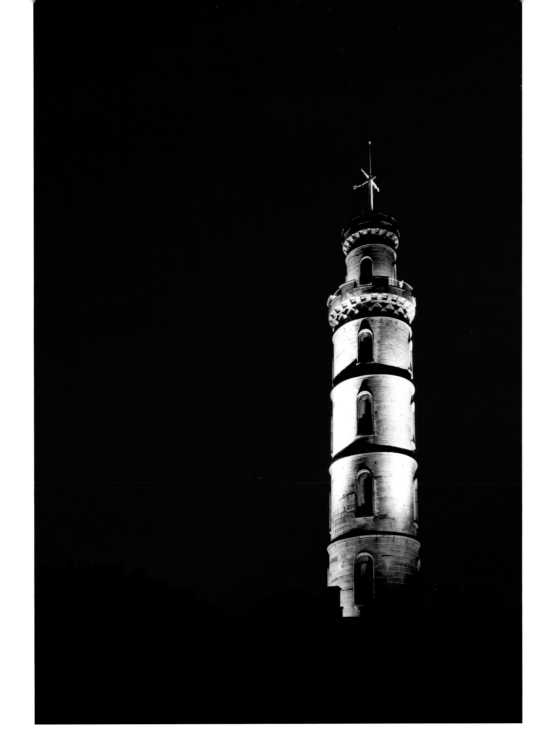

Nelson's Monument on Calton Hill, erected to celebrate Nelson's victory at the Battle of Trafalgar in 1805.

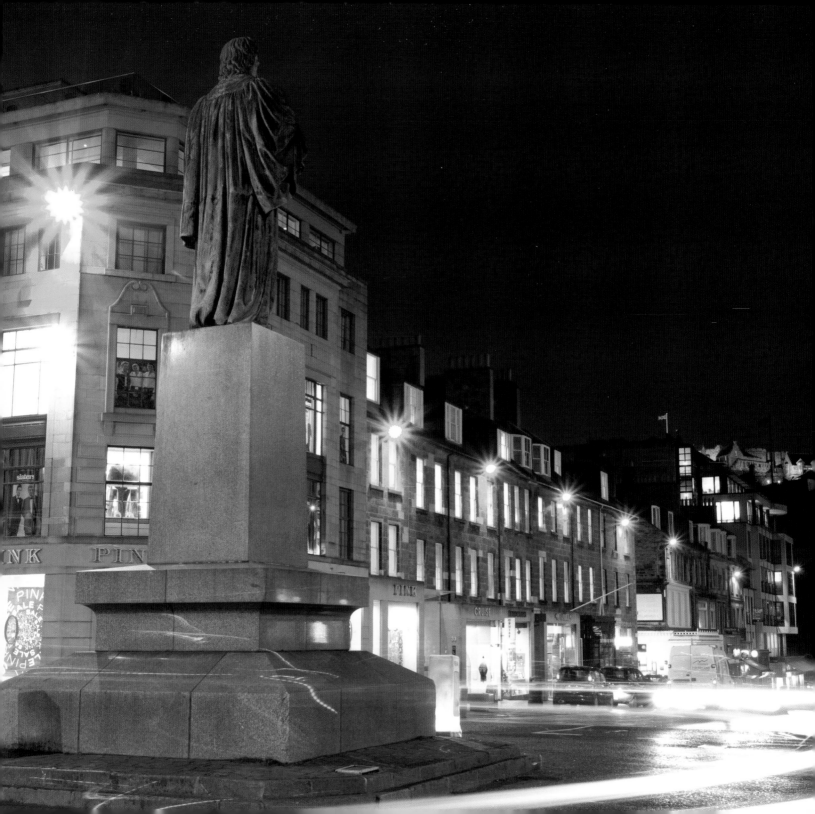

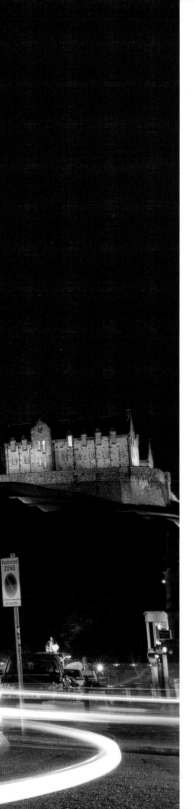

Left:
Statue of Dr Thomas Chalmers, a noted scholar and mathematician, looking down Castle Street towards Castle Hill.

Right:
Edinburgh Castle situated above rush hour traffic on the Lothian Road.

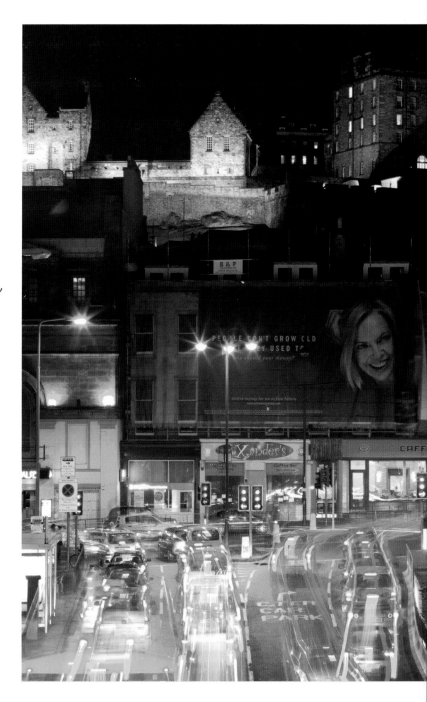

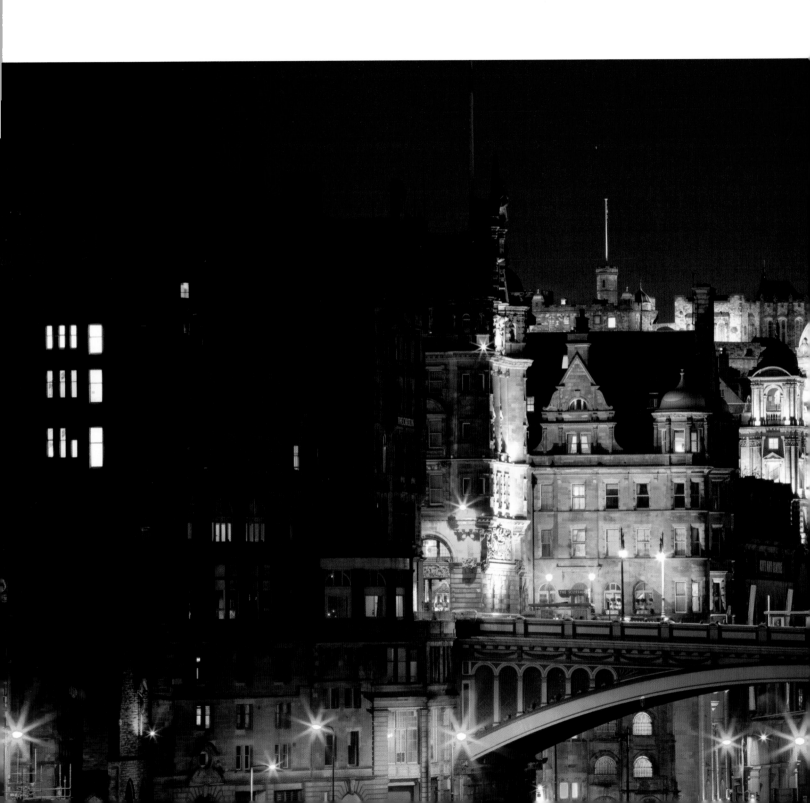

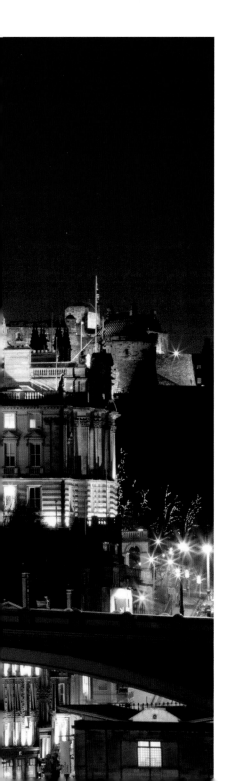

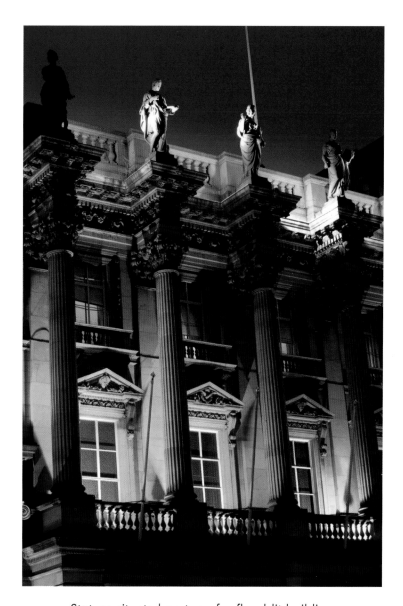

Looking from the east of the North Bridge towards the Castle, Bank of Scotland and Scotsman building in the Old Town.

Statues situated on top of a flood-lit building in St Andrew's Square.

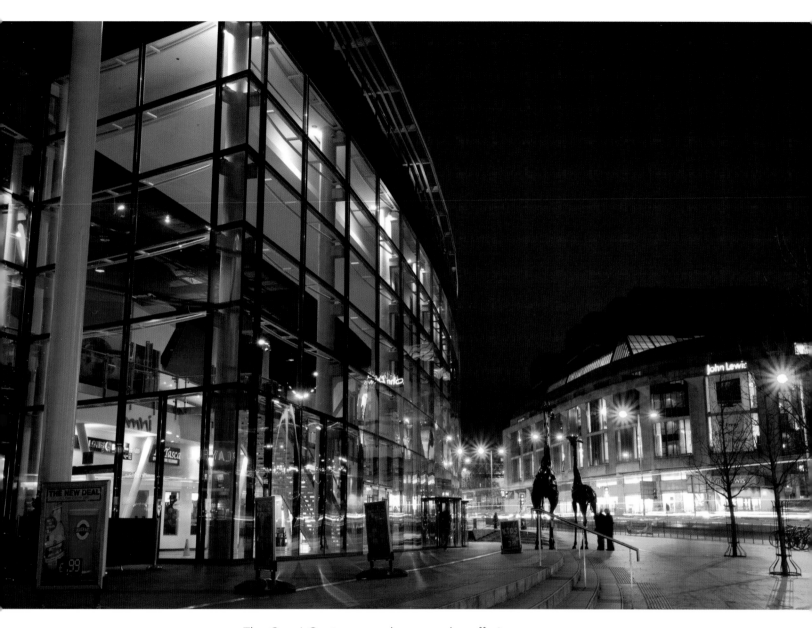

The Omni Centre, a modern complex offering numerous
recreational opportunities in the heart of the city.

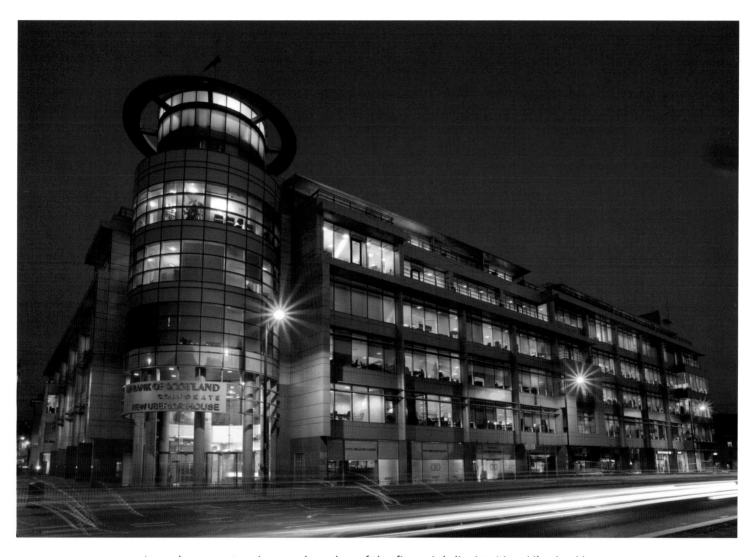

A modern construction on the edge of the financial district, New Uberior House located on Tollcross in the south-west of the City Centre.

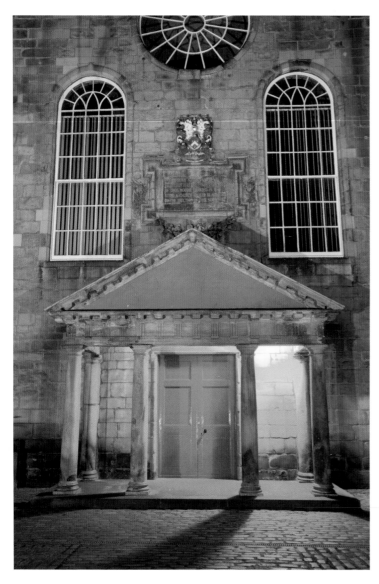

Canongate Kirk, located in Canongate, formerly a separate town before becoming part of Edinburgh in 1856. It was built in 1691 by Scottish architect James Smith.

Cobbled stone road and traditional red telephone boxes in the High Street, part of the historic Royal Mile in the Old Town.

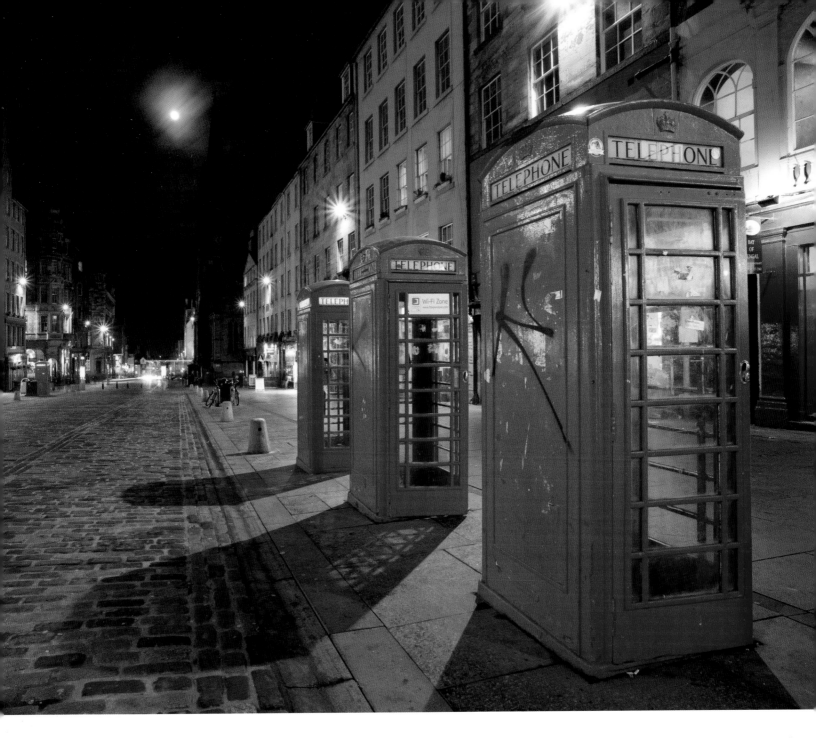

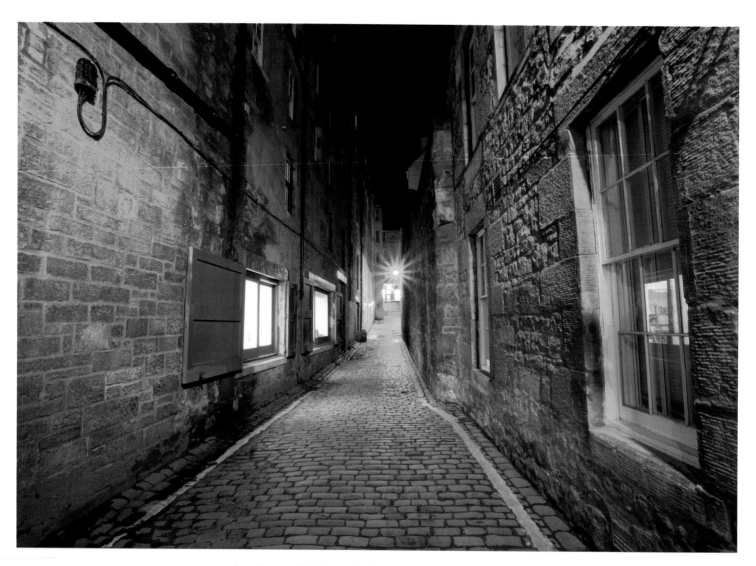

A backstreet Edinburgh alley near the Grassmarket.

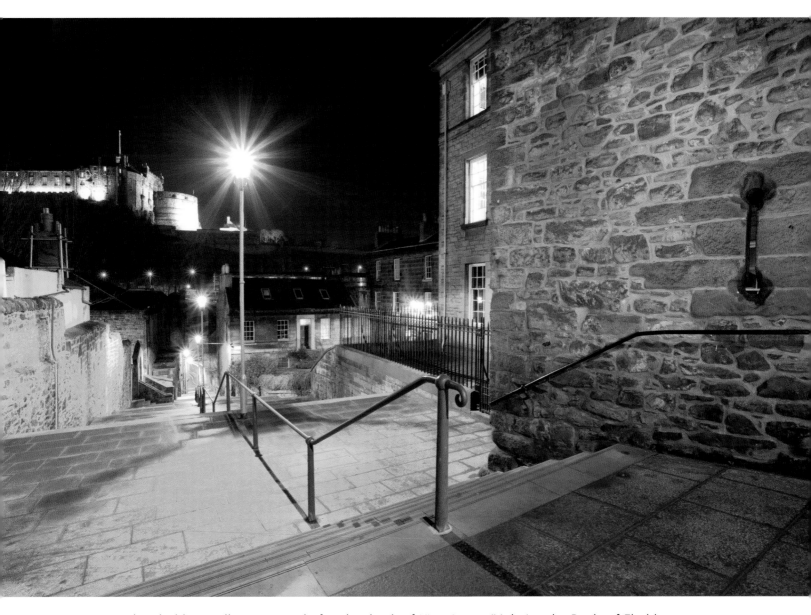

The Flodden Wall, constructed after the death of King James IV during the Battle of Flodden, was constructed as a means of defending the city from invaders. Remains of the wall are visible here and now form part of the Vennel heading towards the Grassmarket.

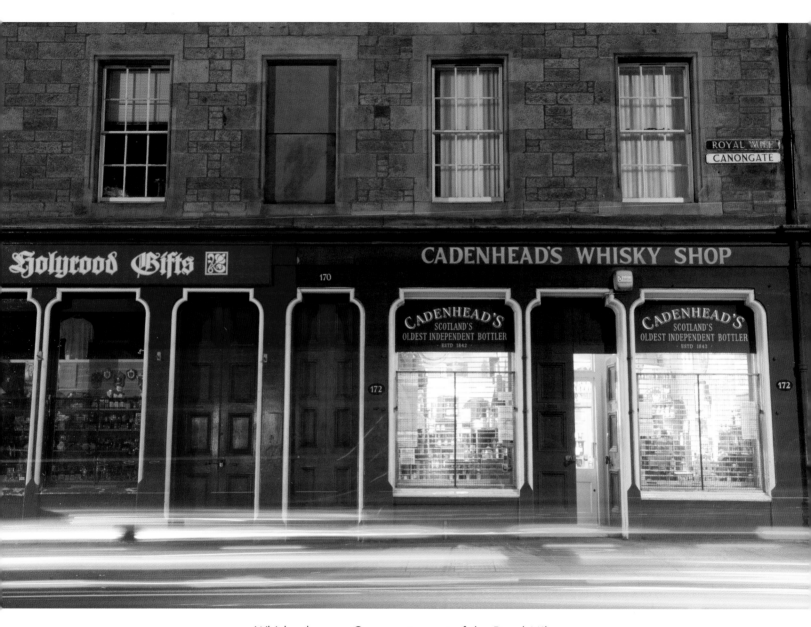

Whisky shop on Canongate, part of the Royal Mile.

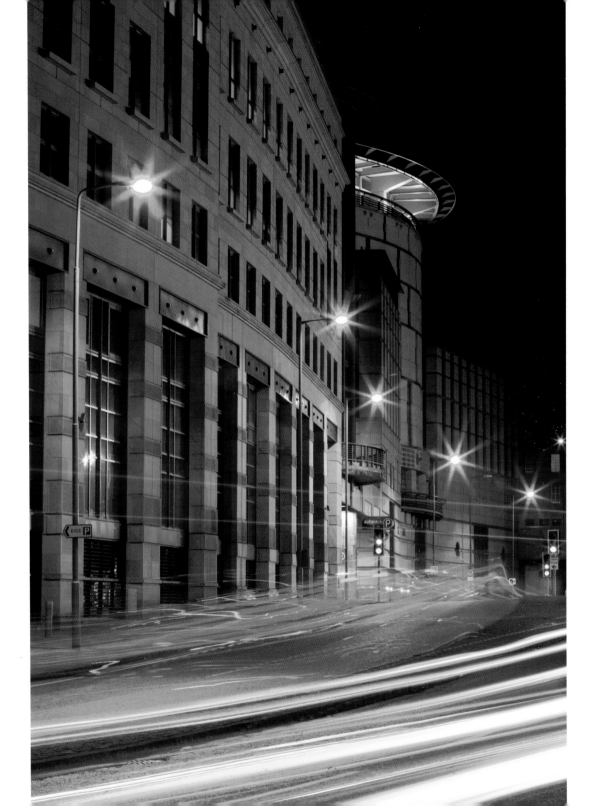

Busy traffic on the West Approach Road running through the financial district.

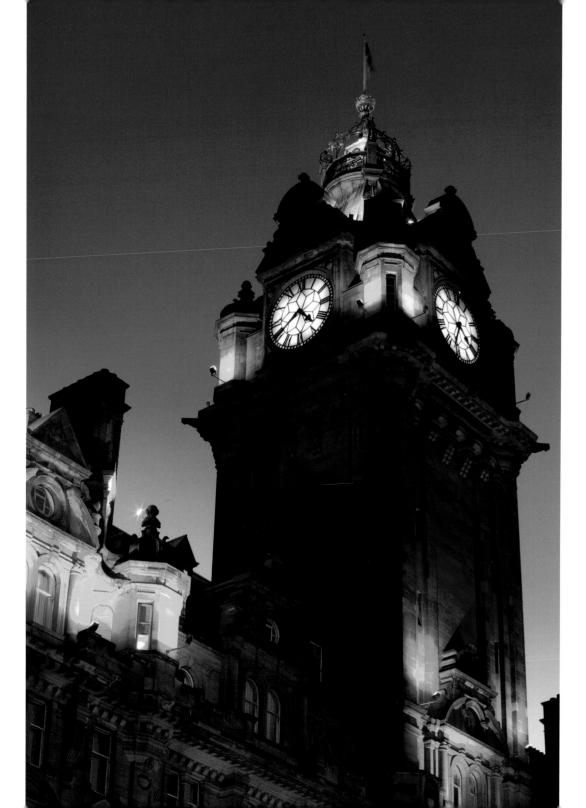

Often referred to as the most photographed clock tower in Scotland, the Balmoral Hotel is an impressive feature of the Edinburgh skyline.

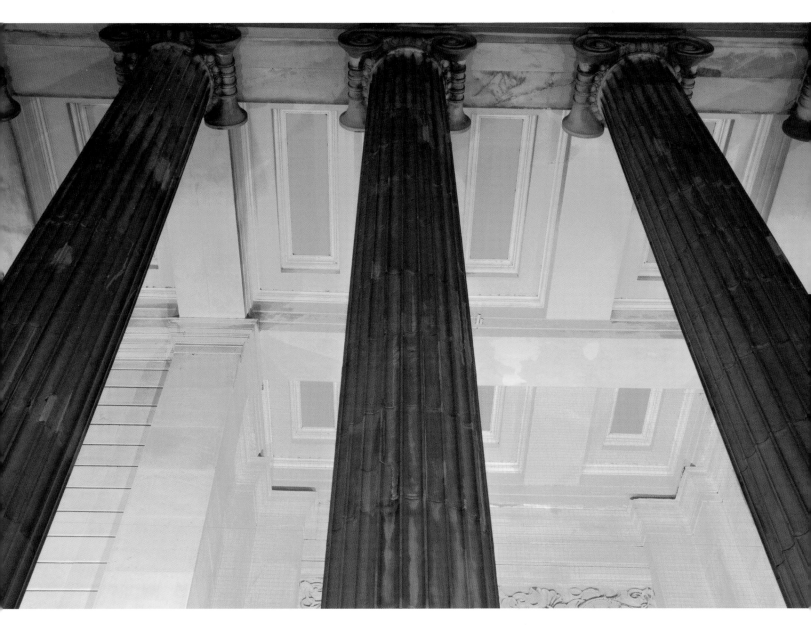

Pillars outside the Museum of the Royal College of Surgeons of Edinburgh.

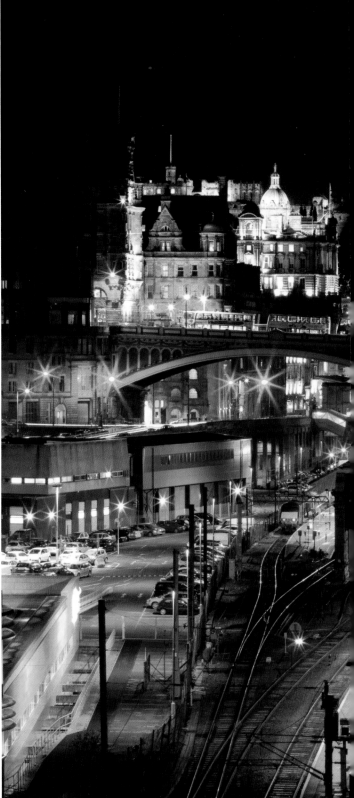

Above:
Looking across the rooftops of a vast array
of new and old buildings.

Right:
Waverley Station, the principal railway station in Edinburgh,
situated beneath the North Bridge linking the two towns.

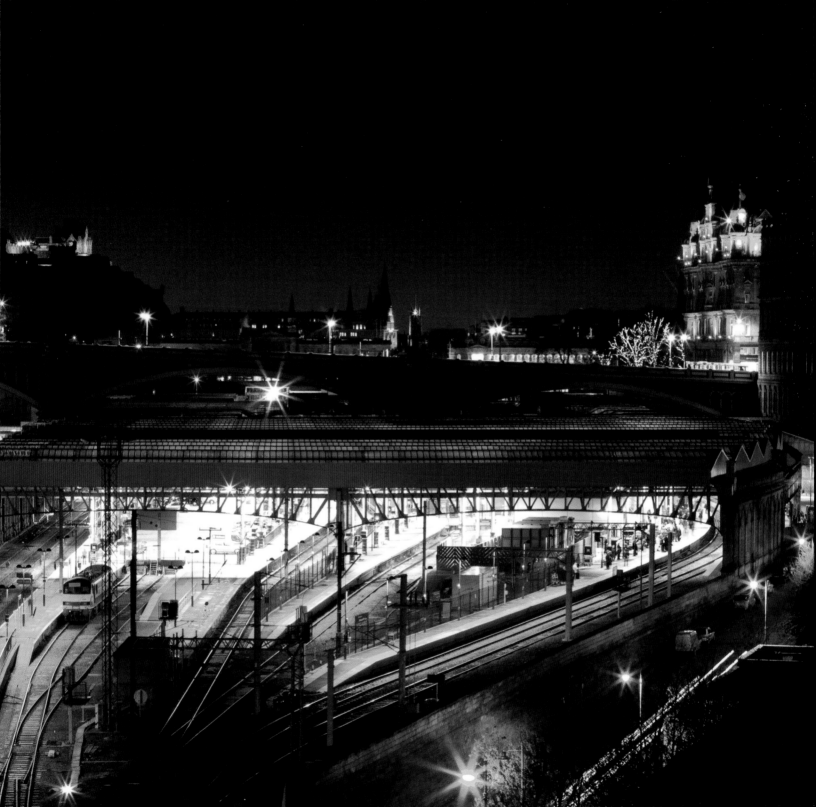

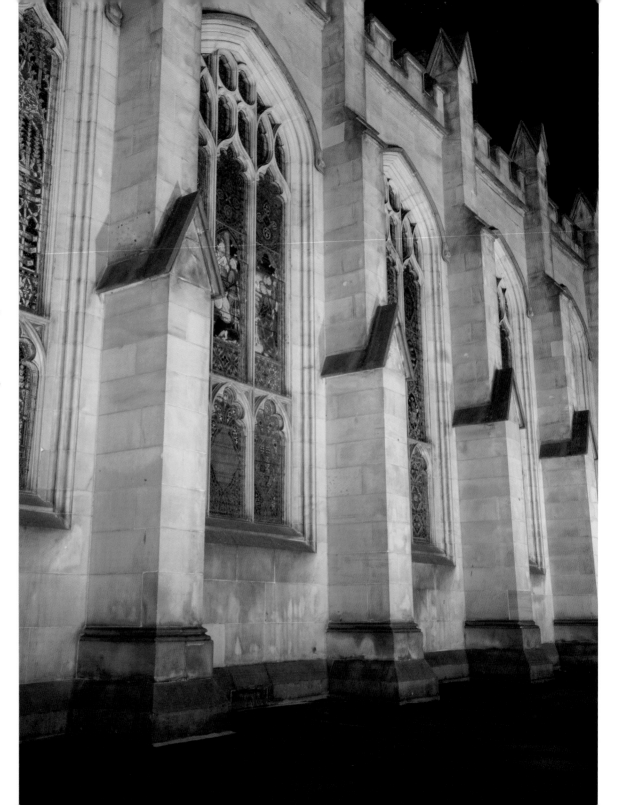

The foundations for the Gothic-style Church of St John the Evangelist were laid in March 1816, with the building finally consecrated in 1818.

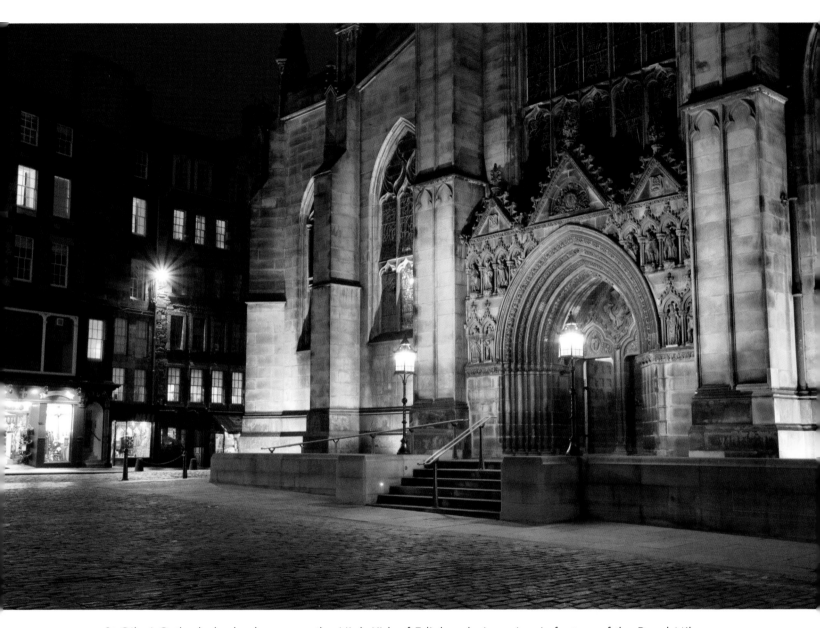

St Giles' Cathedral, also known as the High Kirk of Edinburgh, is an iconic feature of the Royal Mile.

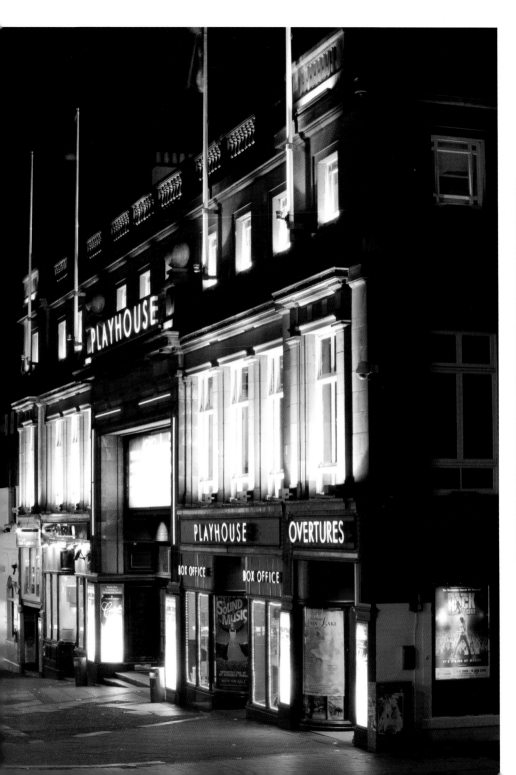

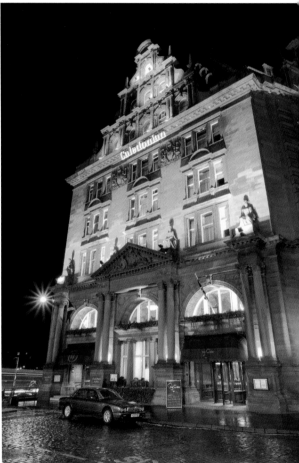

The Edinburgh Playhouse, which originally opened as a cinema in 1929. It was designed by architect John Fairweather who gained inspiration for the design from the Roxy Theatre in New York.

The Caledonian Hilton Hotel near Lothian Road.

Private dwelling near the city centre in the New Town.

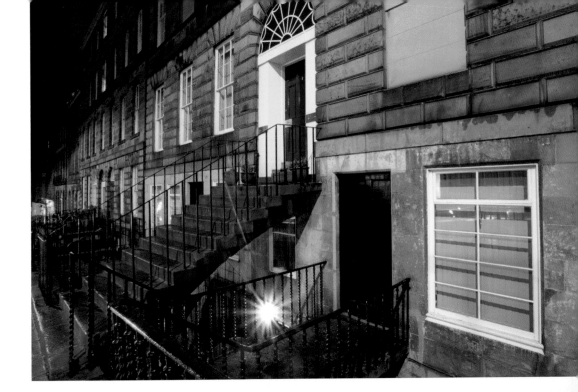

Grand steps forming the entrance to St Stephen's Church.

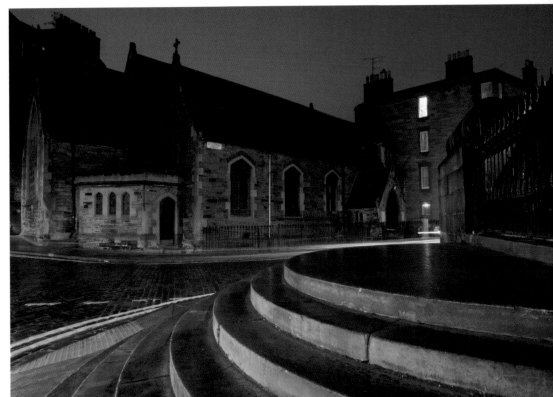

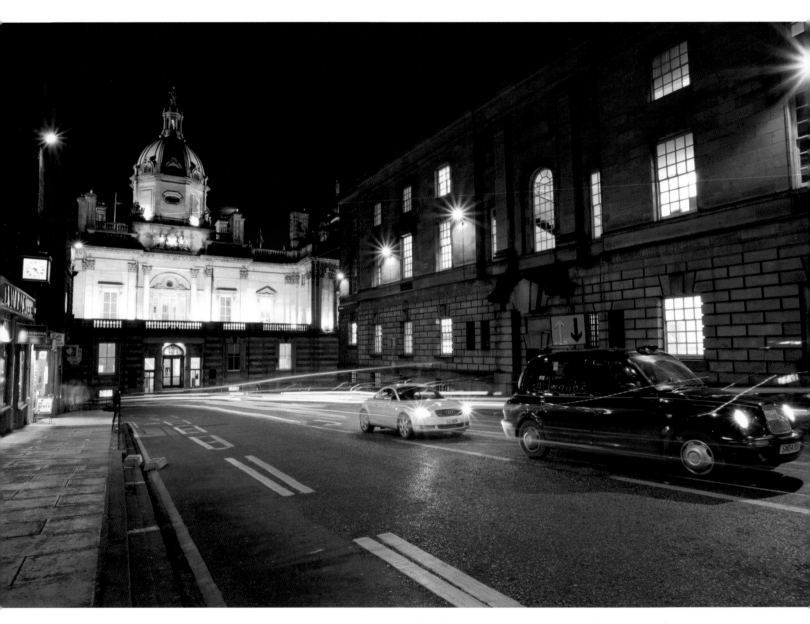

A city taxi waiting in traffic on Bank Street. The Bank of Scotland is prominent with its domed roof.

A church has stood on the hallowed land below Castle Rock since the seventh century when St Cuthbert, a famous Northumbrian Saint, built the first church with mud and wattle. Crossfire between the castle and opposing parties has led to the church being damaged or destroyed on numerous occasions, resulting in several rebuilds with the final church undergoing construction in 1894.

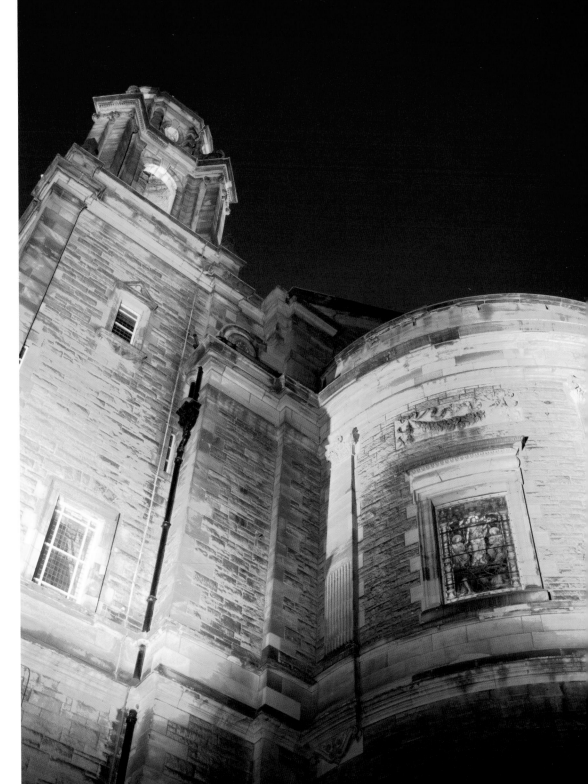

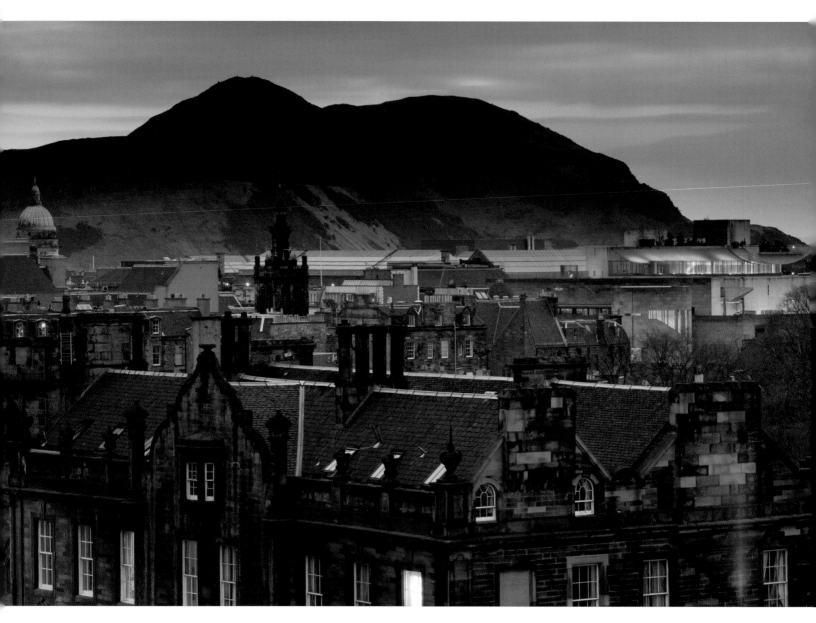

View overlooking the Old Town towards the extinct volcano known as Arthur's Seat.

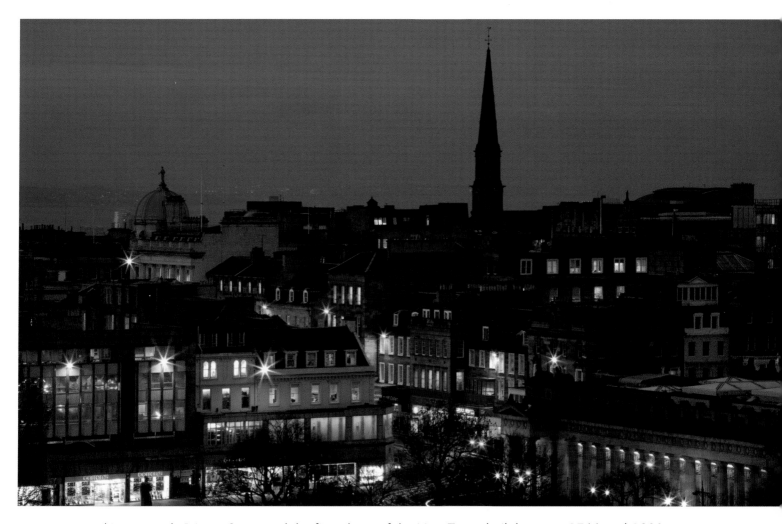

Looking towards Princes Street and the first phase of the New Town, built between 1766 and 1800. The National Gallery complex is prominent in the foreground.

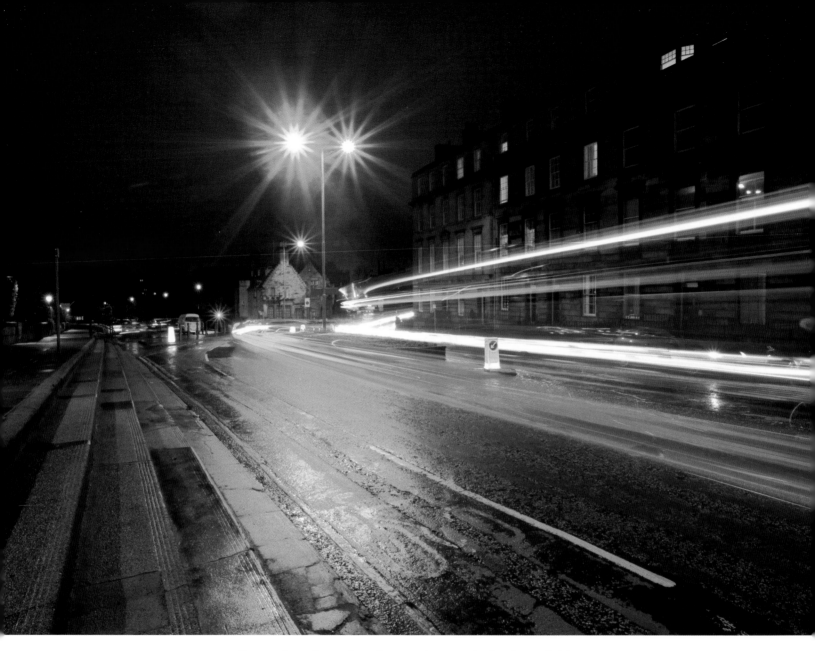

Queensferry Street heading north towards the Dean Bridge.

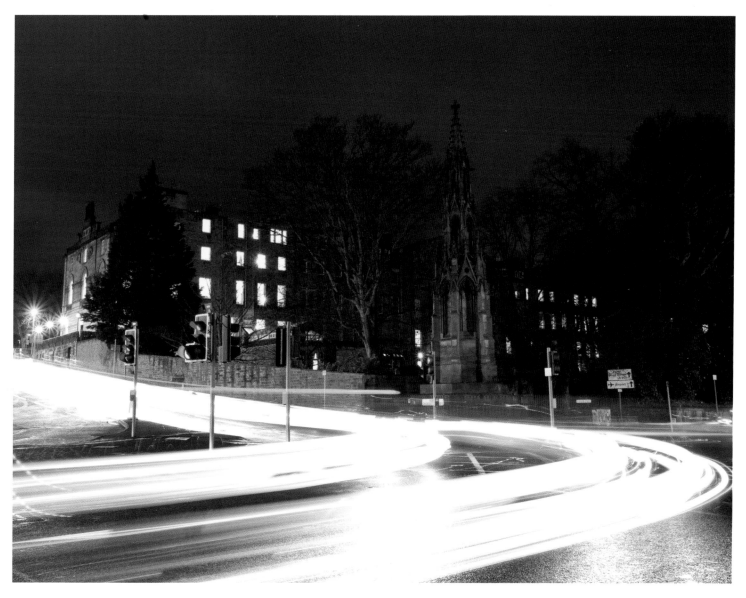

The Gothic spire of the Catherine Sinclair Monument, a memorial to novelist and philanthropist Catherine Sinclair.

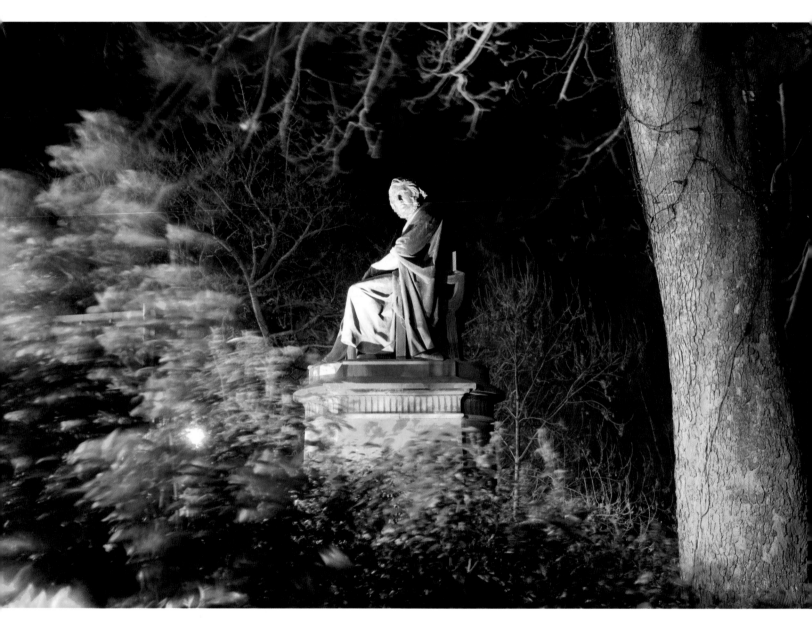

Statue of Sir James Young Simpson, a Scottish doctor who pioneered the use of chloroform as an anaesthetic.

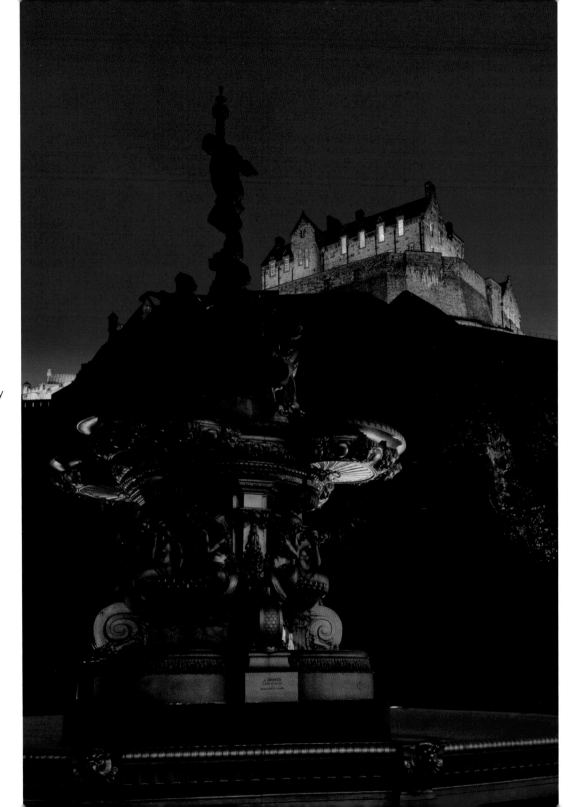

Ross Fountain was cast In France in the early 1860s before being exhibited in London in 1862 and finally being installed in West Princes Street Gardens some ten years later.

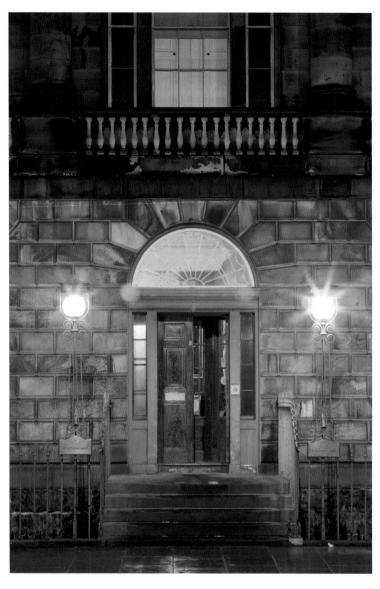

Detailed view of the façade of Saint Andrew's House, a category 'A' listed example of an Art-Deco-style building considered to be one of the finest in Scotland.

Designed by famous architect Robert Adam, Charlotte Square has been described as the finest Georgian square in Europe. No. 28 illustrated here is a gallery, owned and managed by the National Trust for Scotland, displaying a collection of paintings and furniture.

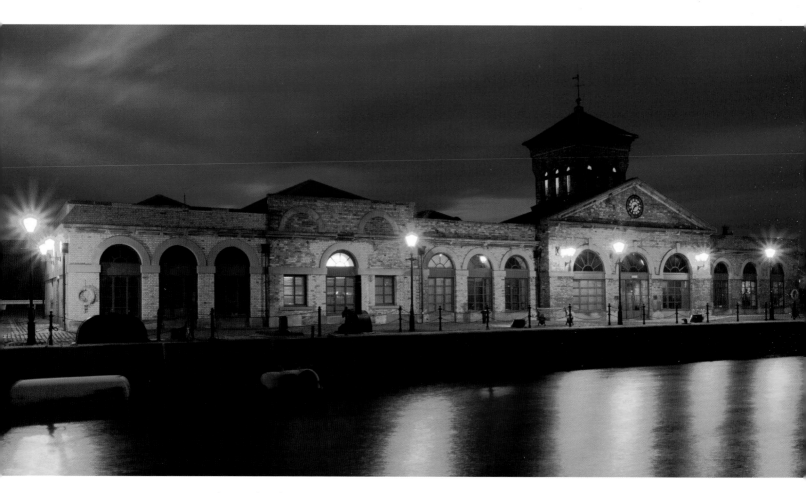

The Hydraulic Pumping Station in Prince of Wales Dock at Leith.
Leith is commonly referred to as the Port of Edinburgh.

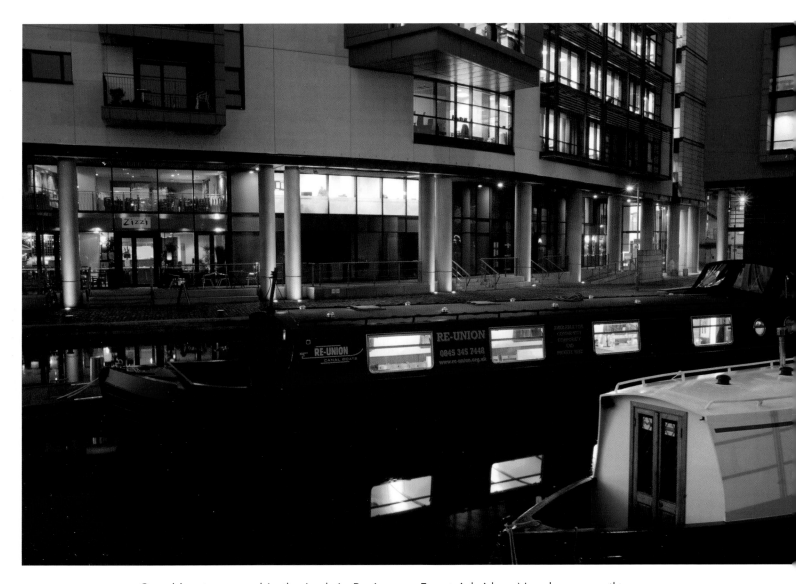

Canal boats moored in the Lochrin Basin near Fountainbridge. Now known as the Edinburgh Quay, the site has seen recent redevelopment and a number of bars and apartments are situated along the quayside.

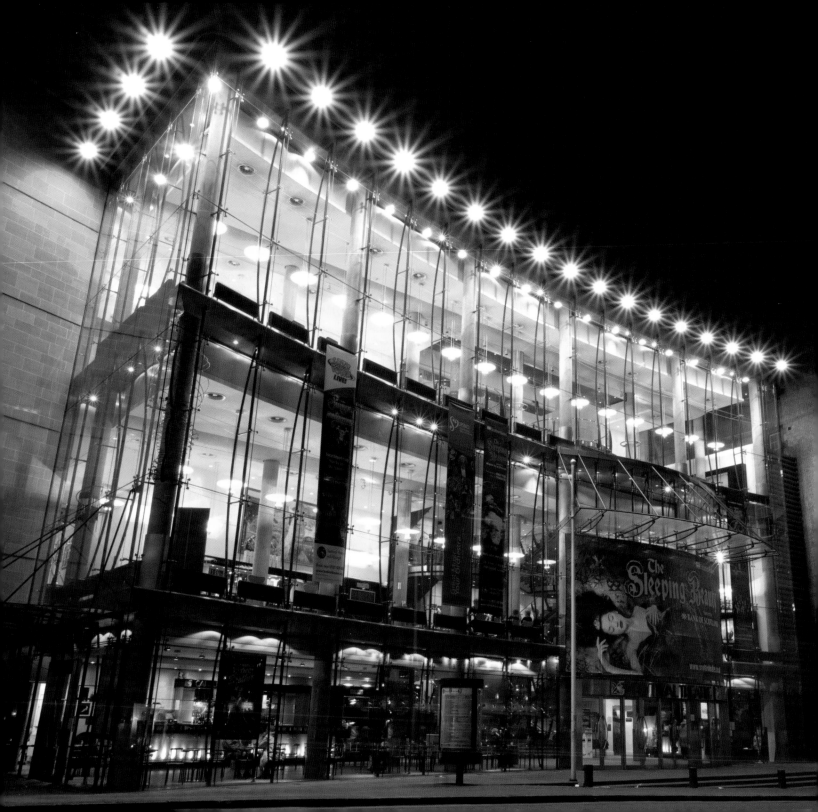

Left:
The modern glass façade of the Festival Theatre. There has been a theatre located here since 1830 making it Edinburgh's longest continuous theatre site.

Right:
The curved frontage of the Georgian Calton Terraces, designed by William Henry Playfair.

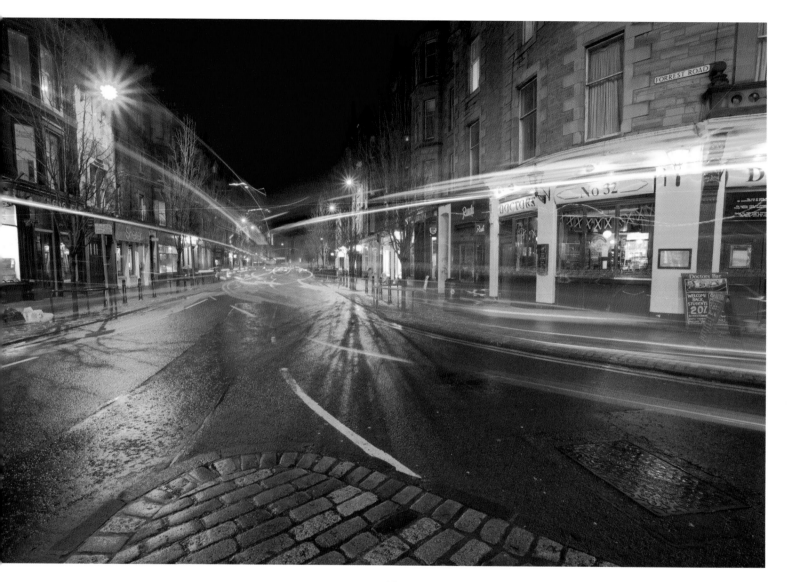

Above:
Forrest Road, a popular student area in the city.

Opposite:
The Balmoral Hotel designed by architect W. Hamilton Beattie and opened in 1902 as
the North British Hotel. The hotel was renamed the Balmoral after refurbishment in the 1980s.

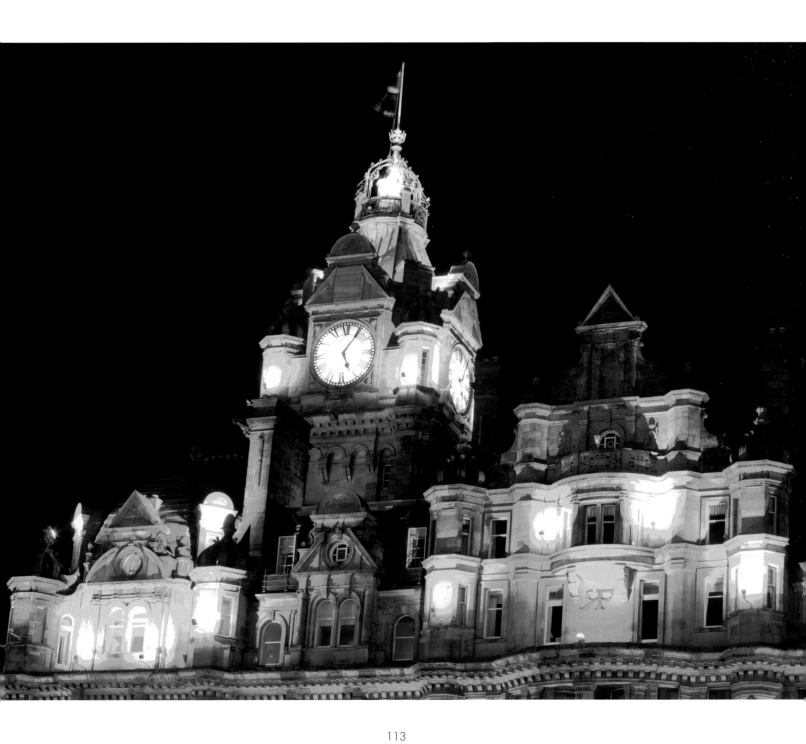

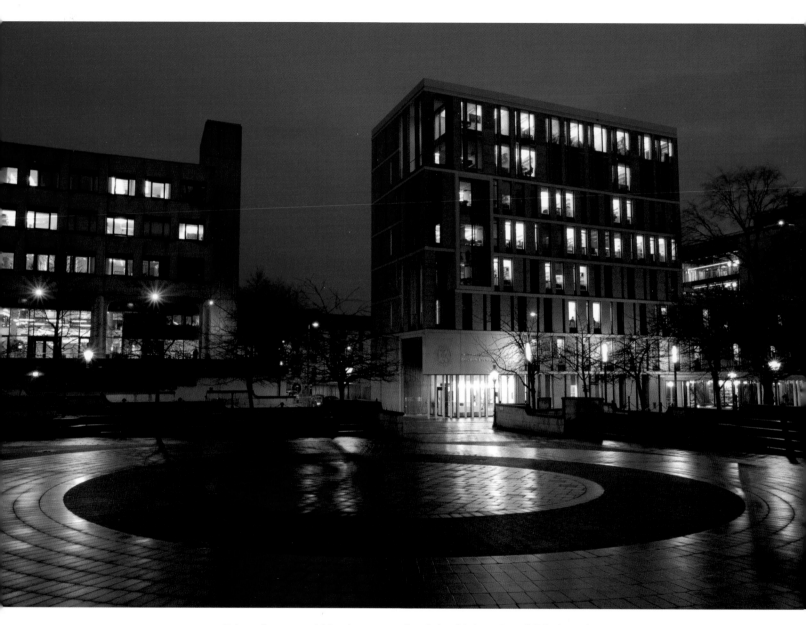

Bristo Square within the grounds of the University of Edinburgh.

Ornate lamp alongside the McEwan Hall, part of the University of Edinburgh complex.

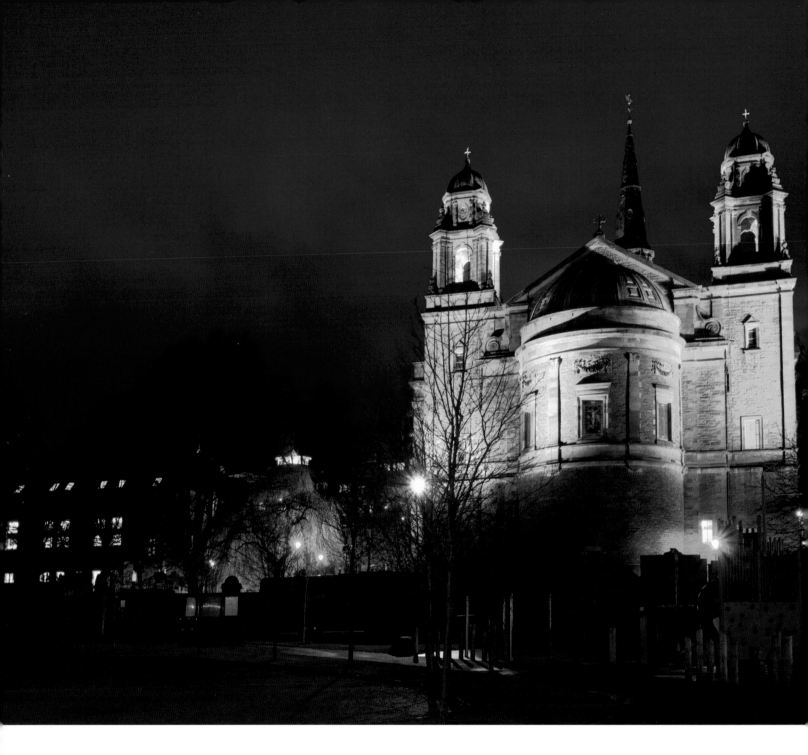

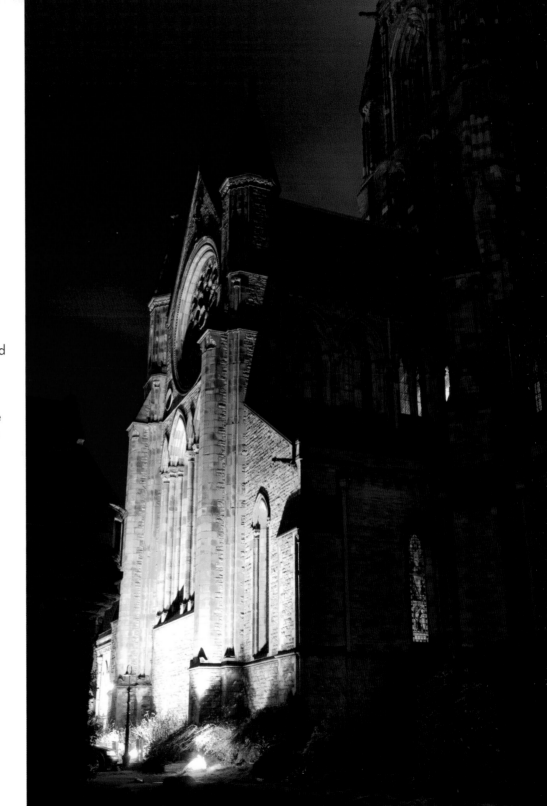

Left:
Saint Cuthbert's Parish Church viewed
from Princes Street Gardens.

Right:
St Mary's Episcopal Cathedral in the
west end of Edinburgh is Scotland's
largest ecclesiastical building.

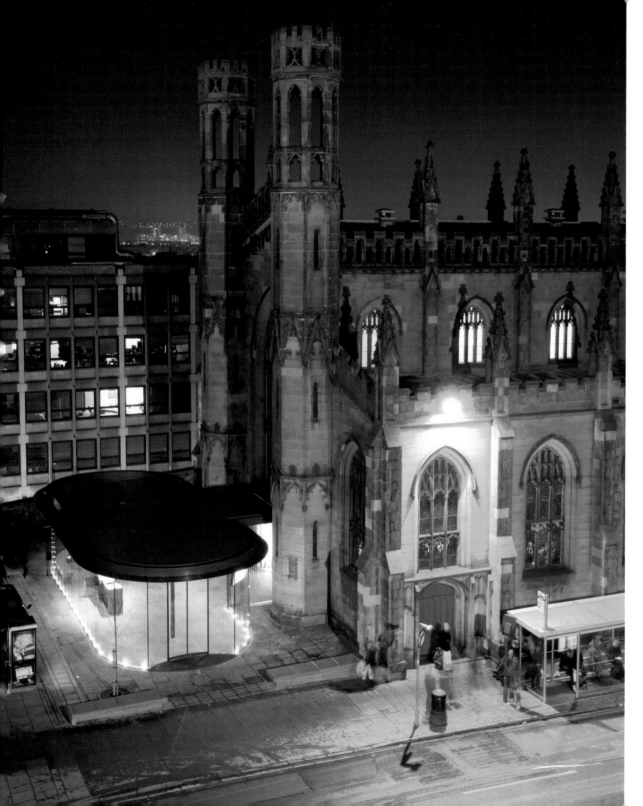

Modern pavilion
designed to express
the progressive
attitudes of the
St Paul's and
St George's Church
on York Place.

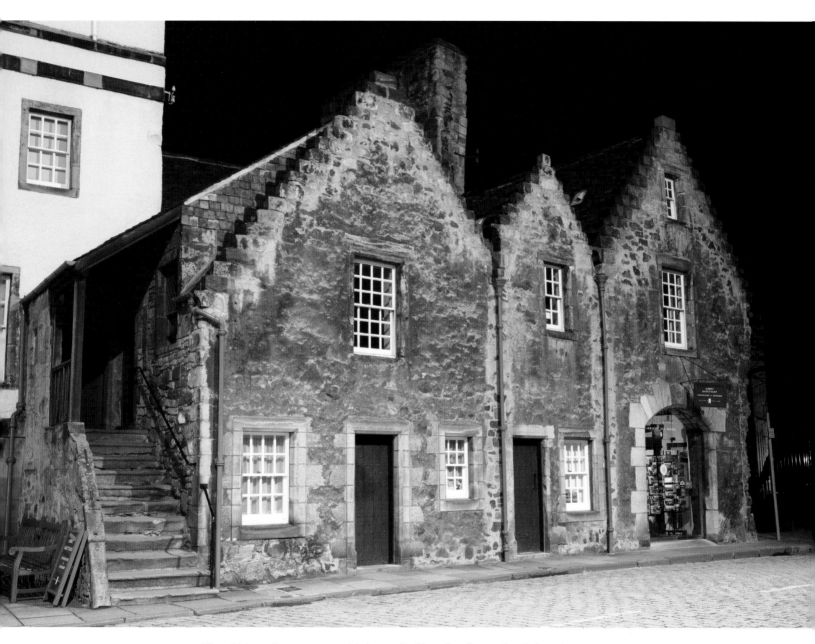

The Abbey Sanctuary at Holyrood offered a five mile defined area
where those in need were provided protection from their pursuers.

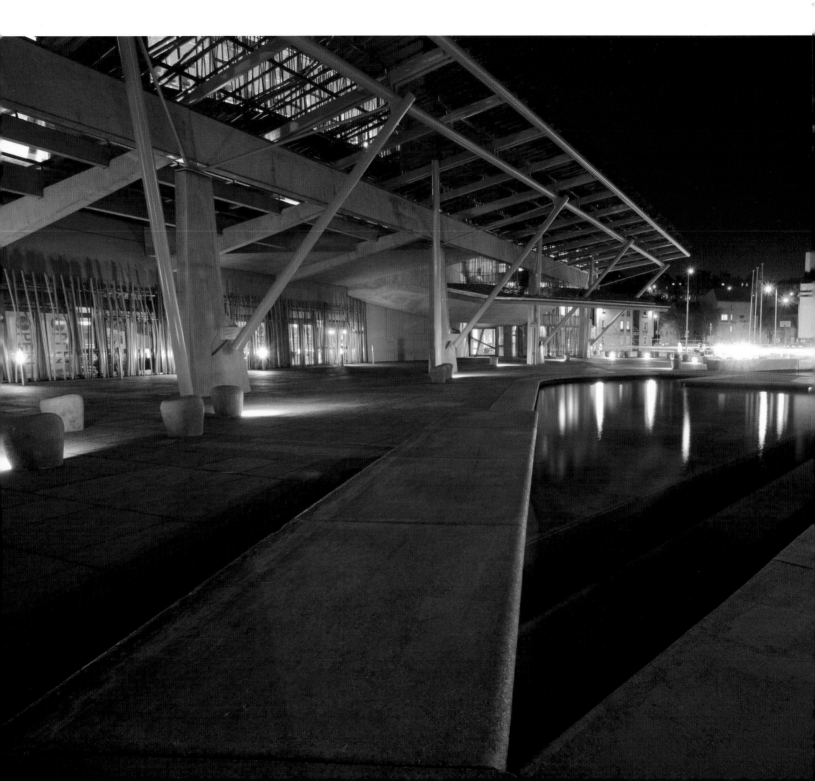

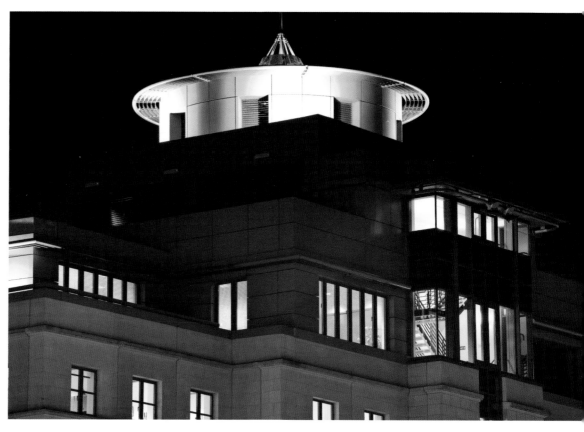

Above:
Modern architecture in the heart of the financial district.

Opposite:
Water feature running alongside the Holyrood Parliament Building.

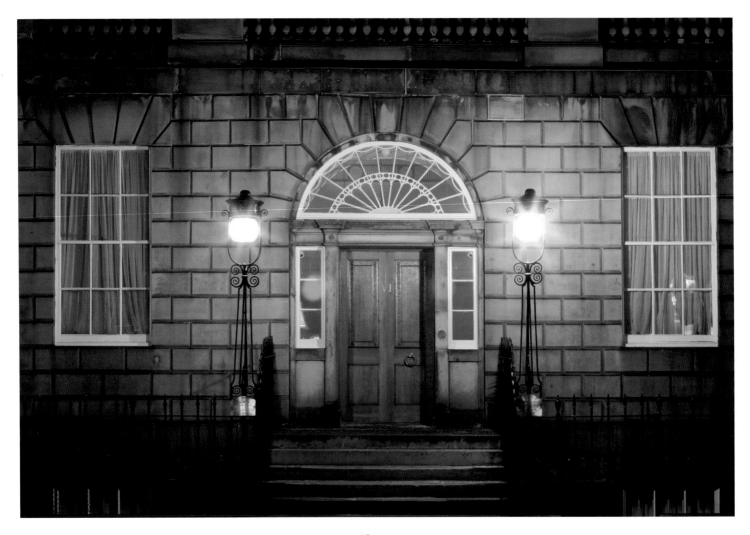

Above:
Located on the north side of Charlotte Square, Bute House was constructed after
the death of the original architect, Robert Adam. Bute House has been
the official residence of the First Minister of Scotland since 1999.

Opposite:
Greyfriars Bobby's Bar, a traditional public house located near the
Greyfriars Kirk and the monument dedicated to Greyfriars Bobby.

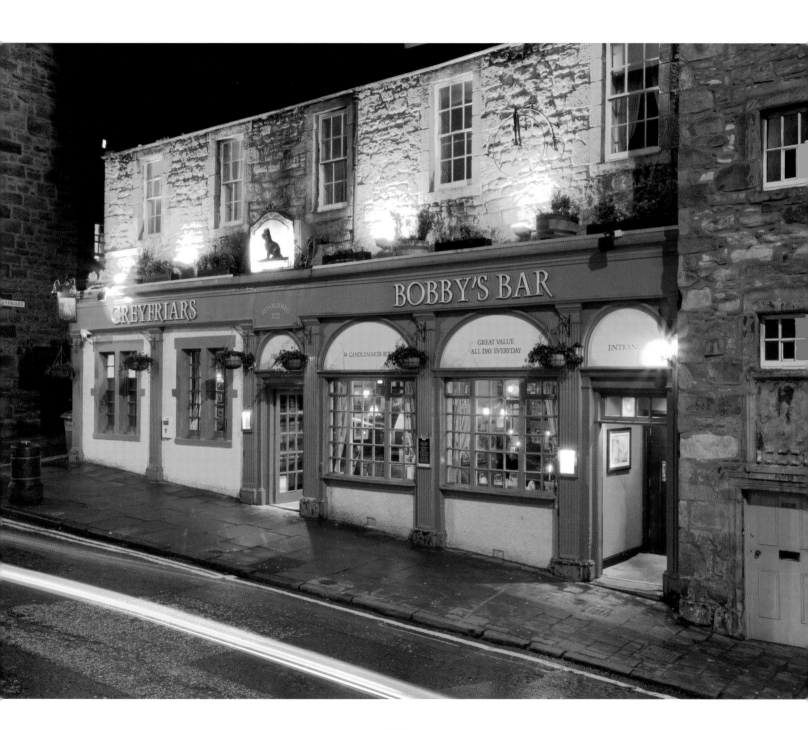

The beautiful Edinburgh skyline with the distinctive landmarks of the Scott Monument, Balmoral Hotel and the Melville Monument.

Taking its name from the cattle markets that were held here, the Grassmarket has also witnessed a number of public executions including the hanging of the Covenanters in the seventeenth century.

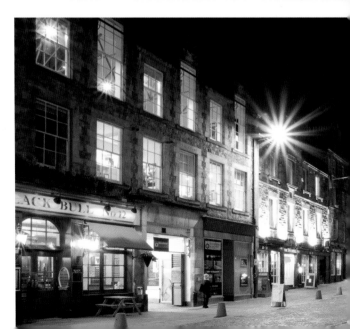

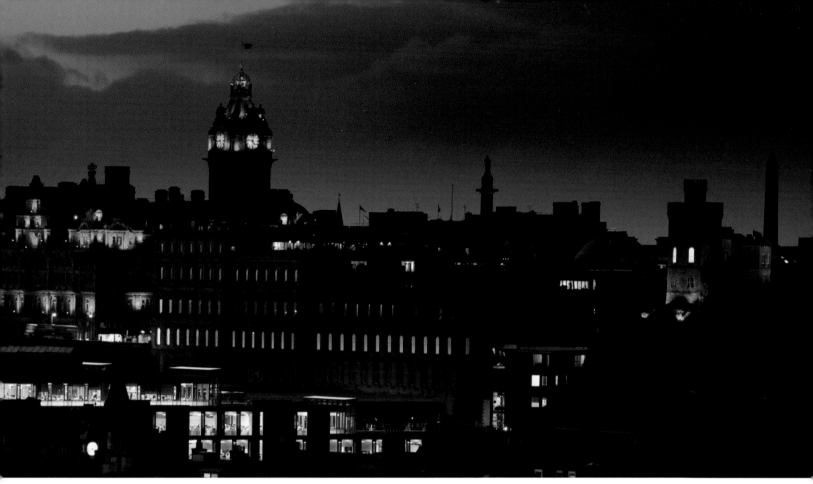

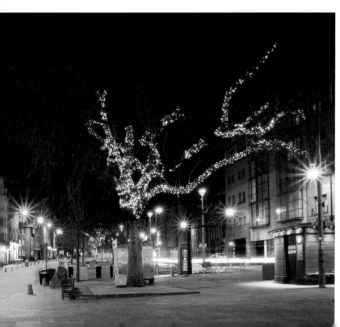

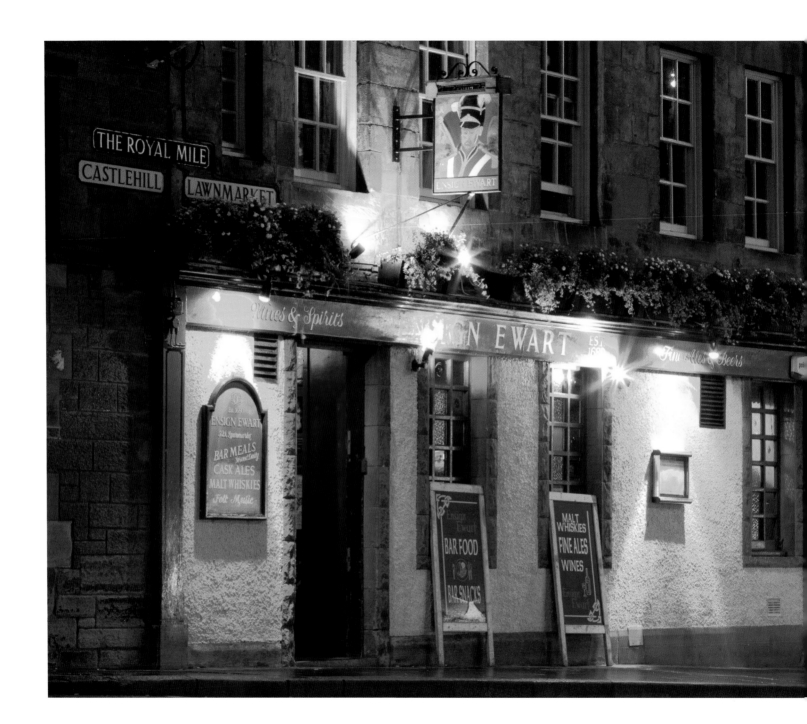

Opposite:
Traditional Scottish Public House on the Royal Mile.

Right:
The Dome, now a bar and restaurant situated in George Street. It was built on the site of the old Physicians Hall which was designed and built by James Craig who planned the New Town of Edinburgh. The foundation stone for the present building was laid in the June of 1844.

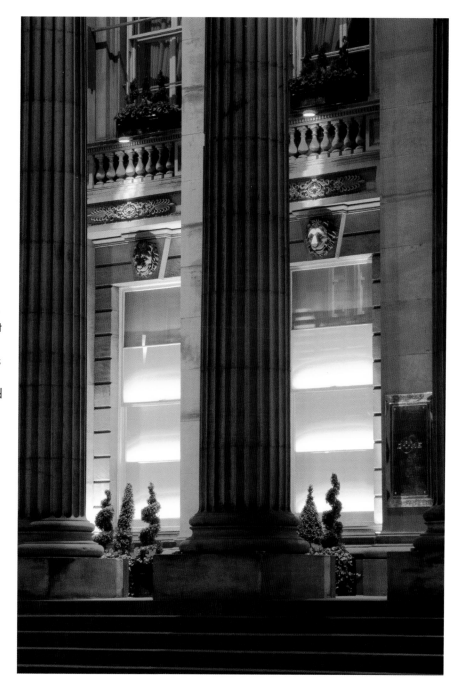

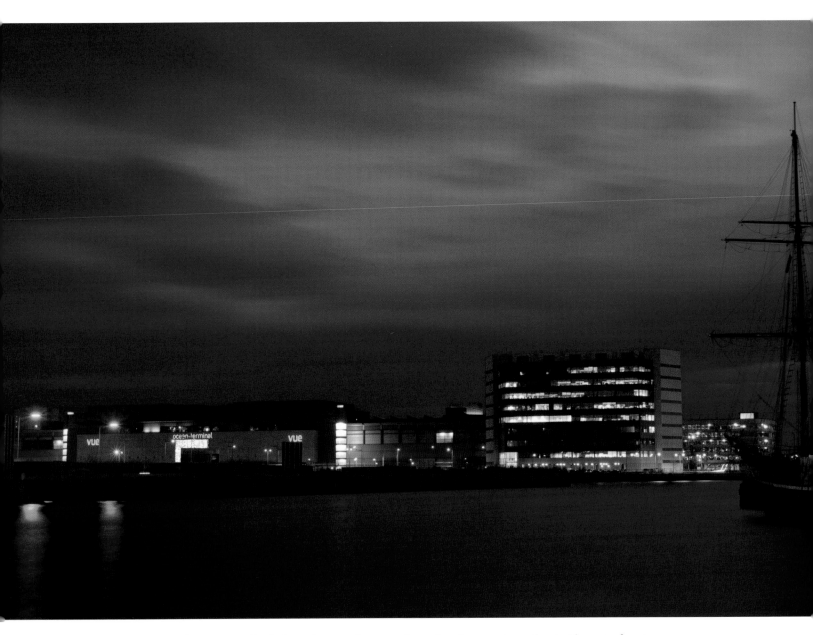

Ocean-terminal shopping mall, a modern development on the Leith waterfront.

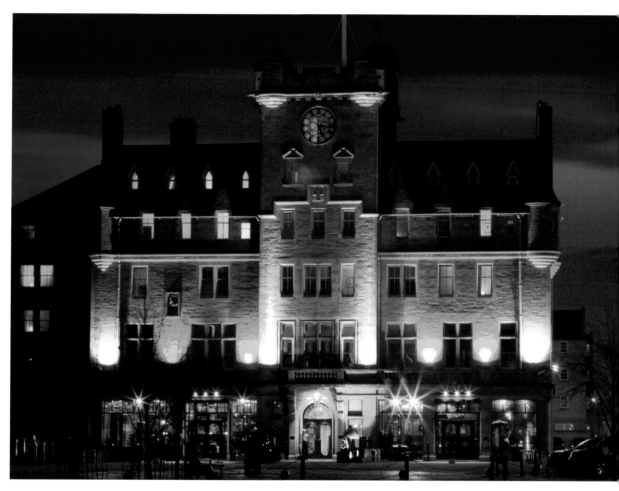

A stylish hotel, formally a Seaman's mission, at Tower Place in Leith.

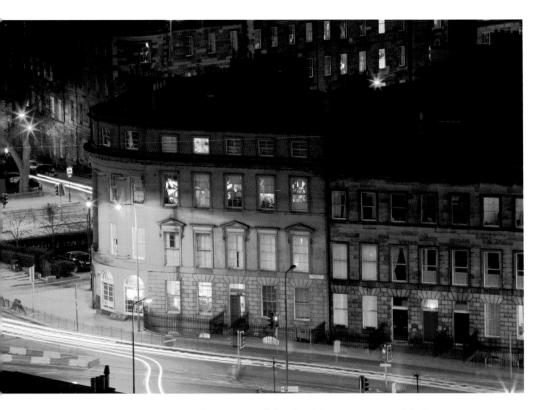

Impressive architecture of the buildings in Leopold Place.

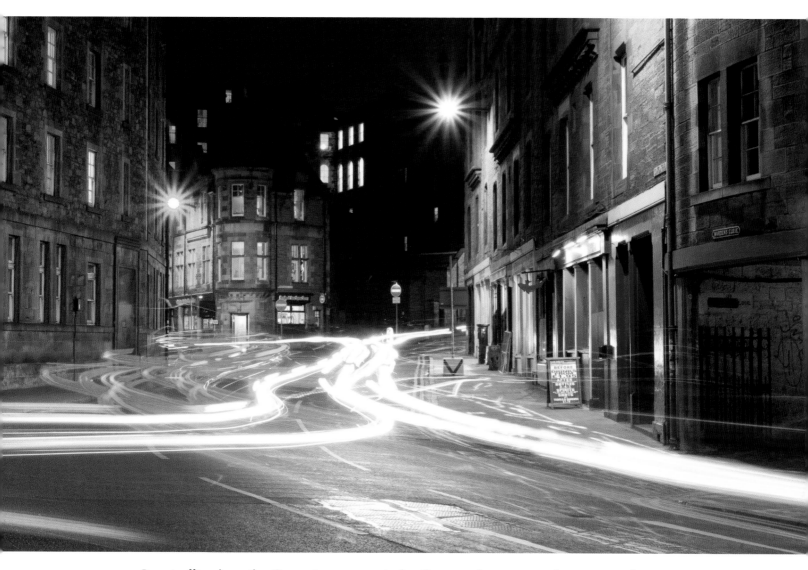

Busy traffic where the Cowgate area meets the Grassmarket – a complete contrast from the cattle that would have been driven through here to the horse and cattle markets held in the Grassmarket weekly between 1477–1911.

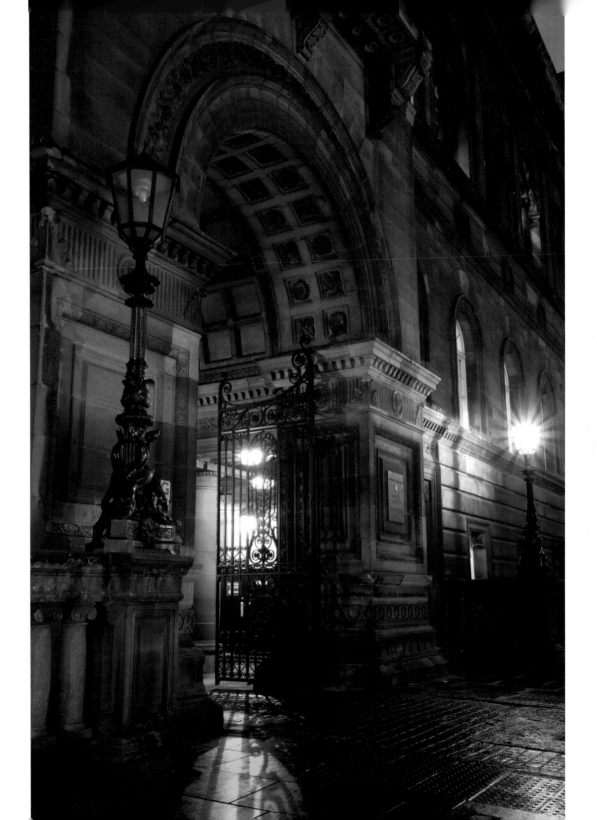

Grand entrance to the University of Edinburgh Medical School.

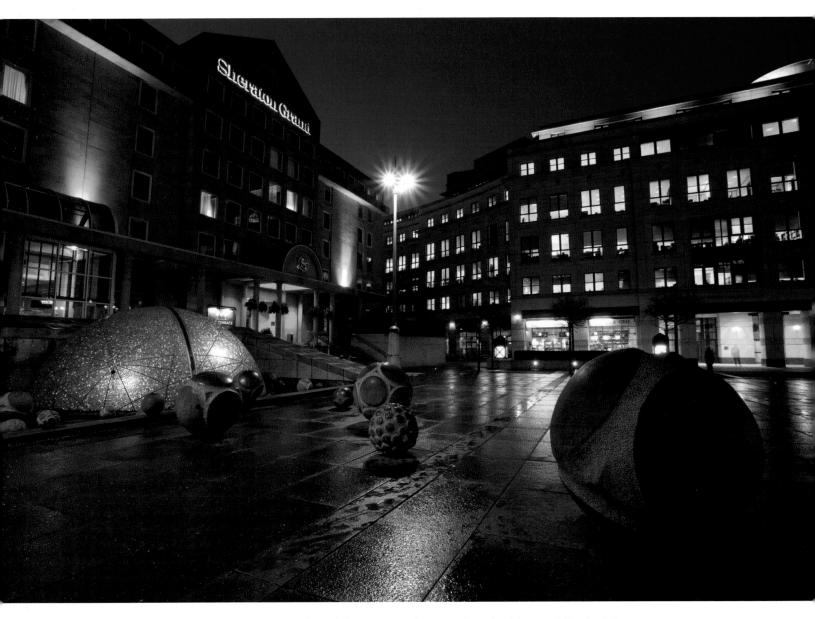

The Sheraton Grand Hotel and the surrounding modern buildings of Festival Square.

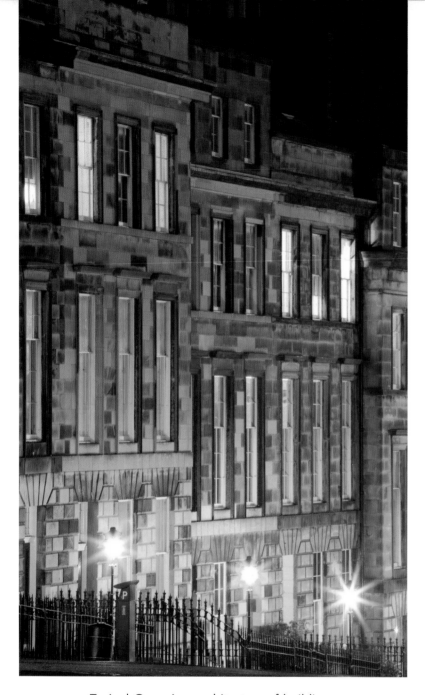

Typical Georgian architecture of buildings
found in the New Town area.

Royal Scots Greys
monument located on
the junction of Princes
and Frederick Street.

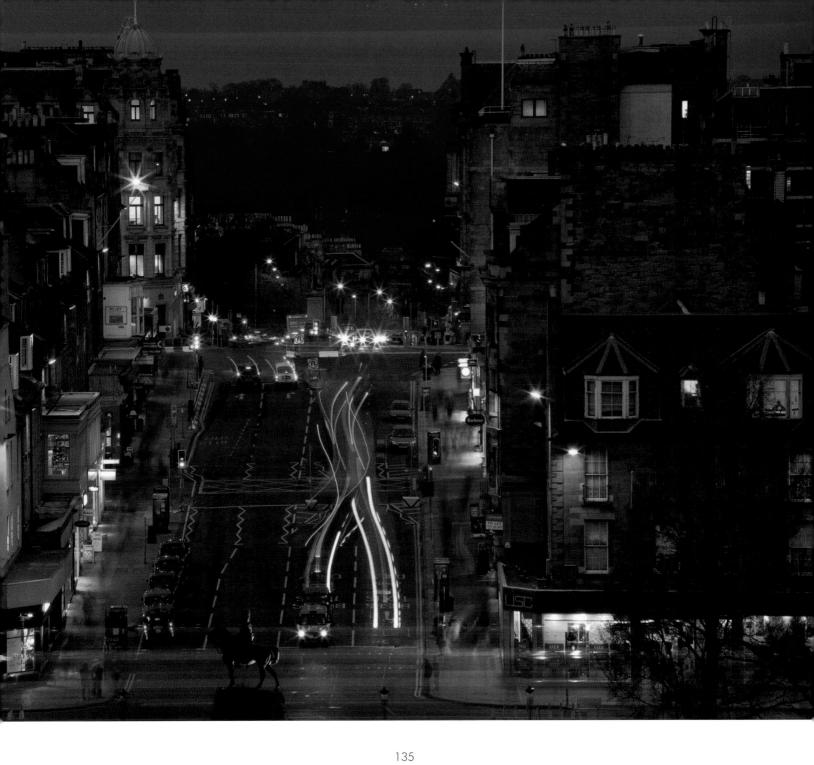

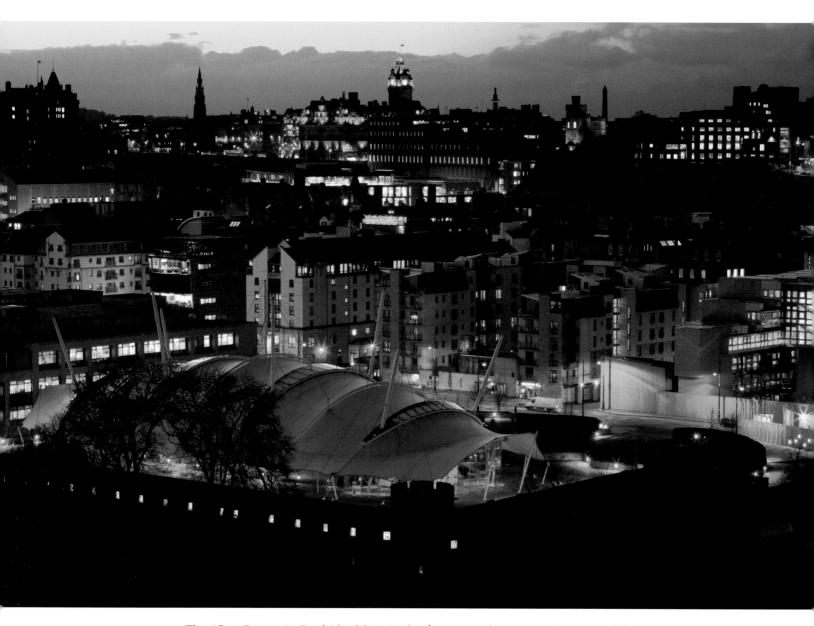

The 'Our Dynamic Earth' building in the foreground was a major part of the
Holyrood urban regeneration plan, built on the former site of a brewery and gas works.

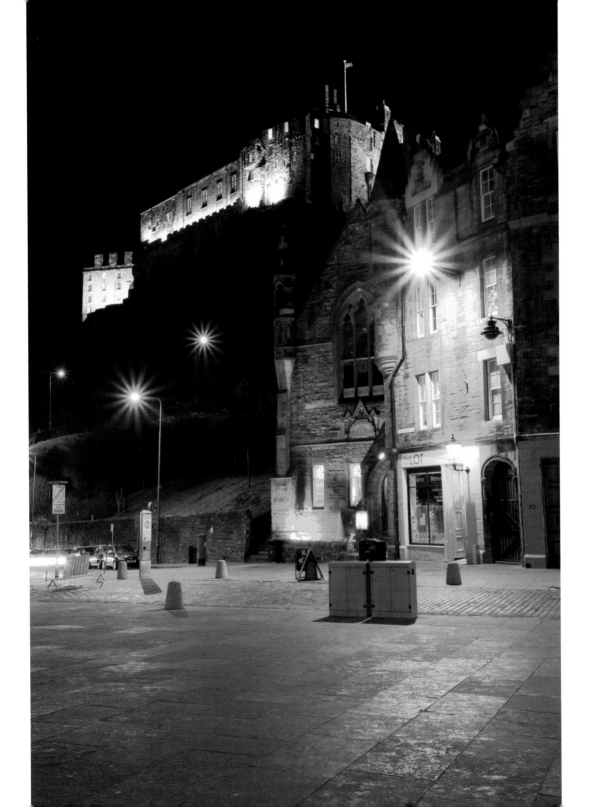

The Grassmarket, an ancient marketplace below Castle Rock.

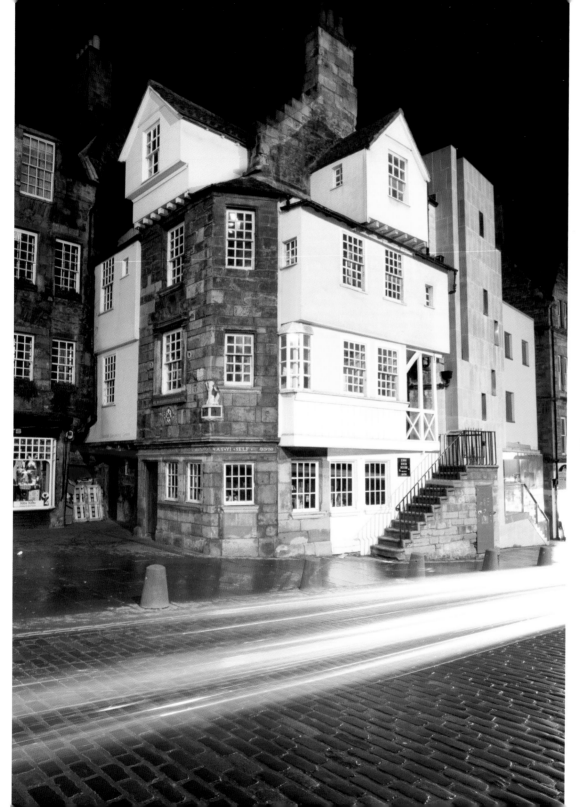

John Knox House on the Royal Mile. John Knox, believed by Mary Queen of Scots to be the most dangerous man in her kingdom, is thought to have lived in this house in Netherbow for the last few months of his life.

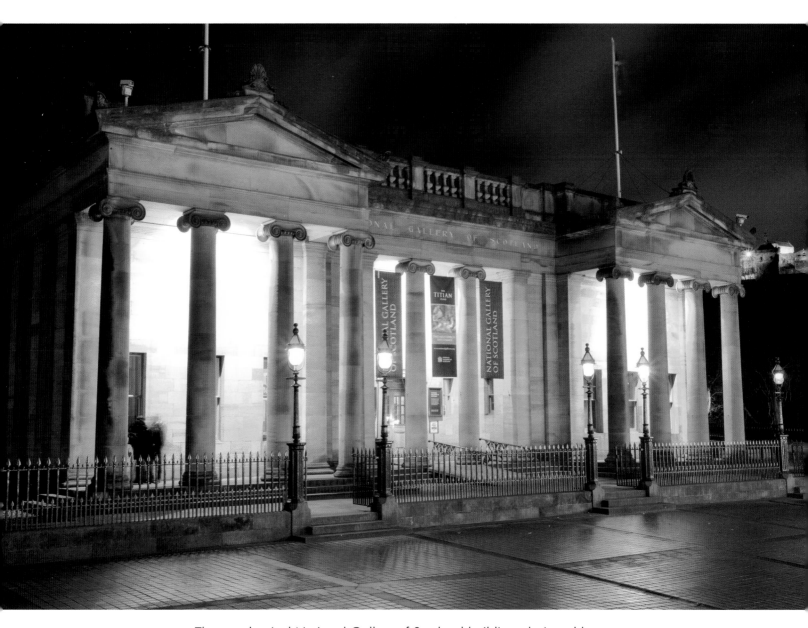

The neoclassical National Gallery of Scotland building, designed by
William Henry Playfair, was opened to the public in 1859.

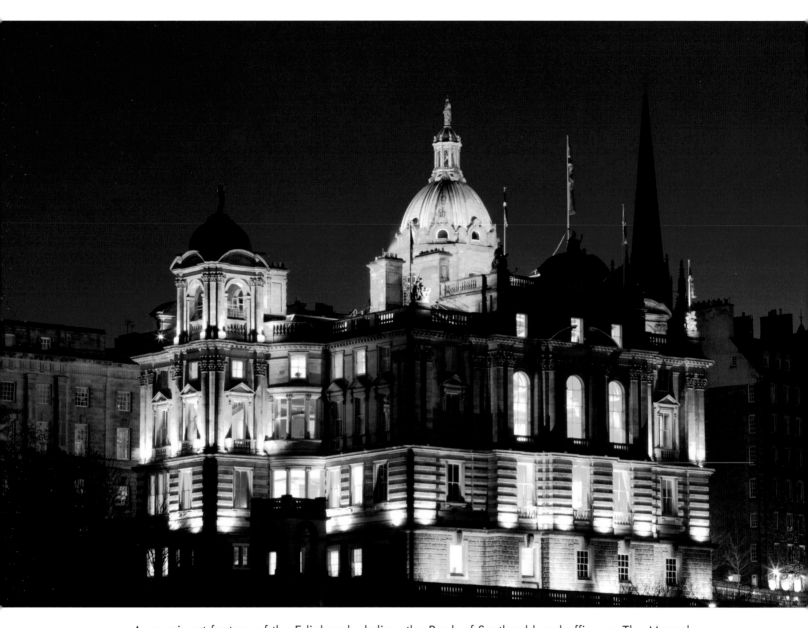

A prominent feature of the Edinburgh skyline, the Bank of Scotland head office on The Mound. Construction of this impressive building was completed in 1806.

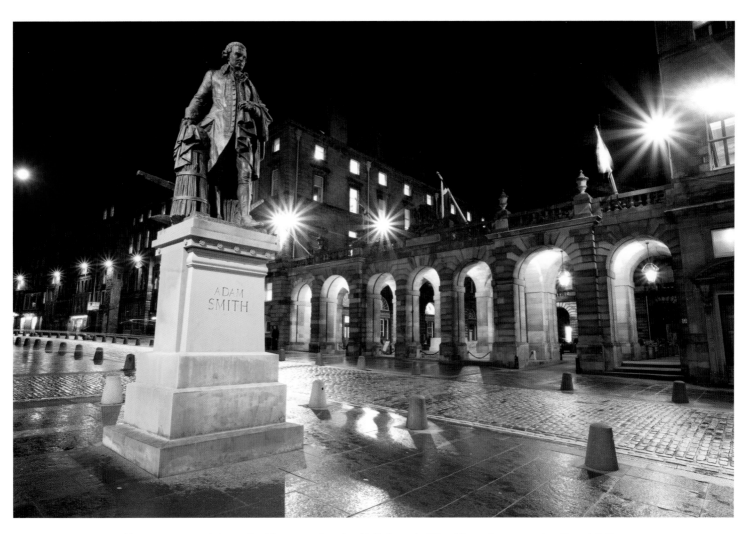

Monument to Adam Smith opposite the Edinburgh City Chambers on the Royal Mile.

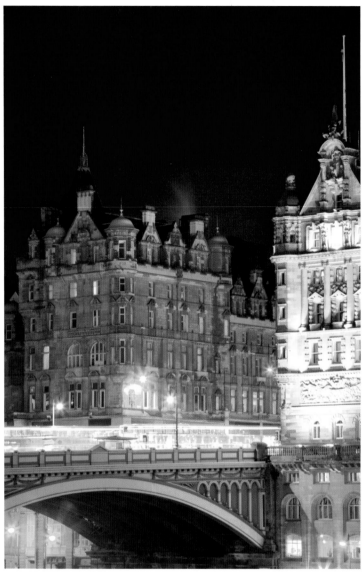

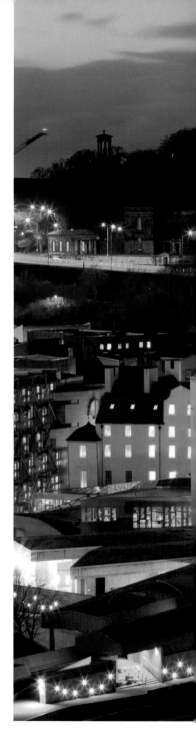

Home of the Scottish Parliament, the design of the Holyrood building was described as "growing out of the land" by architect Enric Miralles.

The current North Bridge linking the Old and New Town districts. The Scotsman Hotel to the right used to be home to the *Scotsman* newspaper and the giant printing presses used to print the paper were said to cause the entire building to resonate.

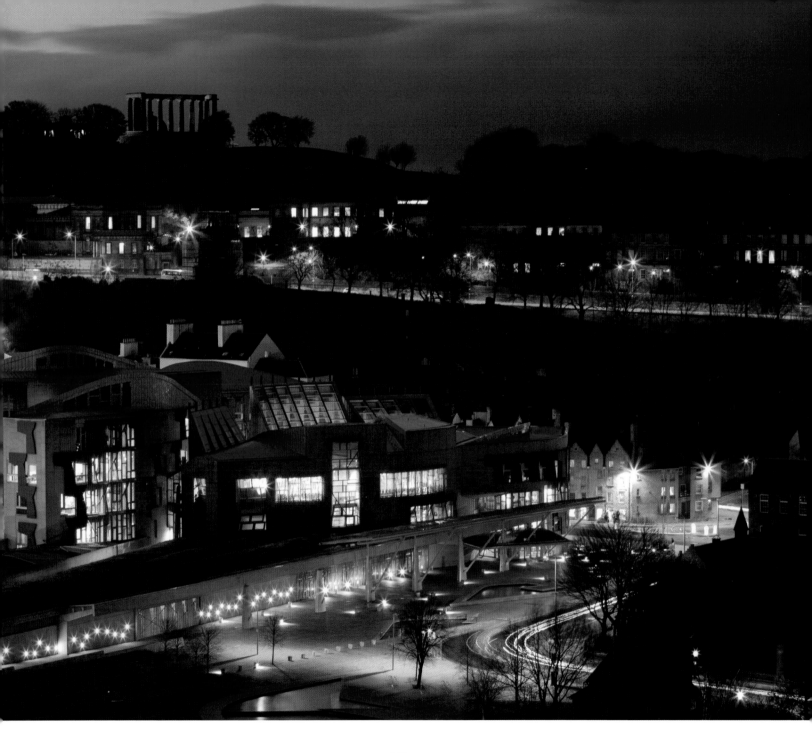

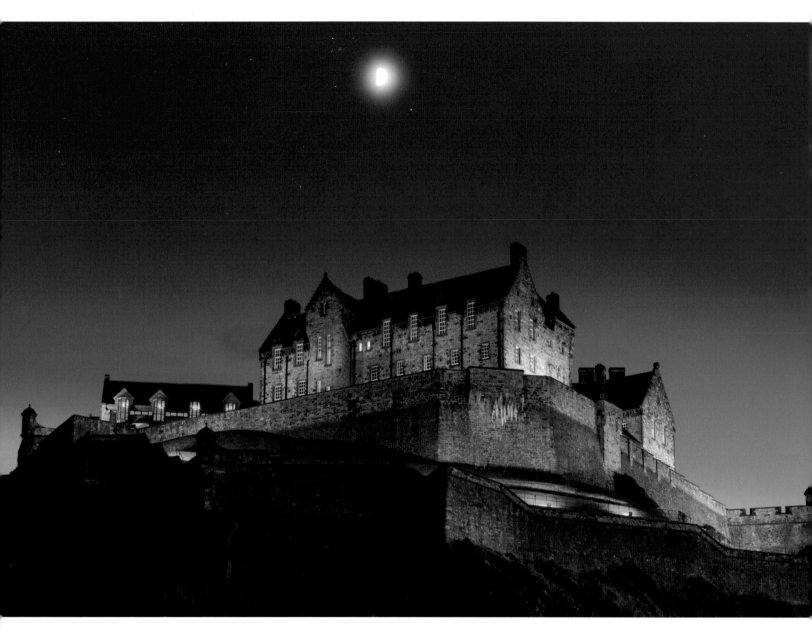

Edinburgh Castle is built upon the remains of an extinct volcano.
Once known as Lookout Hill but now known as Castle Rock,
it has been used as a stronghold for over 3000 years.